VANCOUVER WAS AWESOME

VANCOUVER WAS AWESOME

A Curious Pictorial History

Lani Russwurm

Foreword by Bob Kronbauer, *Vancouver Is Awesome*

Arsenal Pulp Press **Vancouver**

VANCOUVER WAS AWESOME
Copyright © 2013 by Lani Russwurm
Foreword copyright © 2013 by Bob Kronbauer

ARSENAL PULP PRESS
Suite 202 – 211 East Georgia St.
Vancouver, BC V6A 1Z6
Canada
arsenalpulp.com

The publisher gratefully acknowledges the support of the Canada Council for the Arts and the British Columbia Arts Council for its publishing program, and the Government of Canada (through the Canada Book Fund) and the Government of British Columbia (through the Book Publishing Tax Credit Program) for its publishing activities.

Vancouver Is Awesome's name, likeness, and associated logo is used with the permission of Vancouver Is Awesome Inc.

Efforts have been made to locate copyright holders of source material wherever possible. The publisher welcomes correspondence from any copyright holders of material used in this book who have not been contacted.

Photographs used in this book remain the property of copyright holders listed in the captions (key to abbreviations on page 17).

Editing by Susan Safyan
Book design by Gerilee McBride

Printed and bound in Canada

Library and Archives Canada Cataloguing in Publication:
Russwurm, Lani, 1968-, author
Vancouver was awesome : a curious pictorial history / Lani Russwurm.

Includes index.
Issued in print and electronic formats.
ISBN 978-1-55152-525-9 (pbk.).—ISBN 978-1-55152-526-6 (epub)

1. Vancouver (B.C.)—History—Pictorial works. I. Title.

FC3847.37.R88 2013 971.1'33040222 C2013-903252-5
 C2013-903253-3

Contents

ACKNOWLEDGMENTS

WHEN I BEGAN BLOGGING ABOUT Vancouver history in 2008, it was a pretty lonely corner of the internet. Several others have since tapped into Vancouver's past as fodder for online content. I would like to acknowledge the following folks for making this endeavour more enjoyable and productive through sharing their finds, insights, feedback, and enthusiasm: James Johnstone, Jesse Donaldson, Jason Vanderhill, Eve Lazarus, Keith Freeman, Rebecca Bollwitt, Stevie Wilson, Jeremy Hood, Blizzy63, Glenn A. Mofford, Diane Makaroff, Scott Beadle, and Will Woods.

Although writing and blogging usually means sitting alone in front of a computer screen, many people have given me encouragement, inspiration, and/or support in some way. A partial list includes John Belshaw, Tom Carter, Aaron Chapman, Mike Cleven, Wayde Compton, David Cunningham, Charles Demers, Robin Folvik, Kim Glennie, David Goodwin, Tom Hawthorn, Terry Hunter, Clint Kay, Mark Leier, Dale McCartney, Gordon McLennan, Irwin Oostindie, Lianne Payne, Juliana Relja, April Smith, Anna Sribnaia, Althea Thauberger, Teresa Vandertuin, and Savannah Walling.

One of the wonderful things about researching history is that the librarians and archivists that make this work possible tend to be some of the nicest and most helpful people on the planet. Thank you to the staff at the various repositories for helping me to track down photographs. The City of Vancouver Archives in particular has gone the extra kilometre to make the raw material of Vancouver's history widely available. Thank you also to Larry Wong, John Atkin, James Loewen, and Paul Yee for providing me with specific photos from their collections.

Brian Lam, Gerilee McBride, and Cynara Geissler from Arsenal Pulp Press have been a pleasure to work with. Susan Safyan deserves a special thank you for her skillful and diligent editing and for saving *Vancouver Was Awesome* from many of my blunders. Credit for any residual errors belongs solely to me.

Thank you to Bob Kronbauer and *Vancouver Is Awesome* for proposing and championing the project in the first place, and for staying awesome.

Finally, I'd like to thank my family for their encouragement and support over the years. *Vancouver Was Awesome* is dedicated to my darling daughter, Sophia.

FOREWORD

WHEN WE LAUNCHED THE VANCOUVER is Awesome website in early 2008, the concept was simple: celebrate Vancouver and everything that makes it awesome, despite all of the awful crap going on around us. Its mantra of "No Bad News" took flight when I returned to the city following a five-year stint working in Los Angeles. I was incredibly thankful to be able to come back to this wonderful place to live. But I found it all too easy to find Vancouverites writing about the problems that they had with the city—the web is and will always be rife with various complaints, critiques, and bad news in general—but for the life of me, I couldn't find an online resource that highlighted and catalogued all the things that ultimately keep us here in Vancouver, and, of course, draw us back. So, on a whim, with a group of volunteers (some of whom are with our organization to this day), I started Vancouver Is Awesome. The rules were simple: 1. Only post stories about what makes Vancouver awesome. 2. No nudity. I didn't want the site to contribute to the deafening howl of general naysaying, nor further the objectification of women; there was already too much of both online.

Over the years, using the same basic but now more refined principles, the website has evolved into a full-fledged media company. We now have a business model in place that will ensure we stick around for the long-term. We publish an annual print magazine for free. We've launched "Is Awesome" sites with partners in other Canadian centres like Toronto, Whistler, and Calgary. The blog wins awards year after year and our social media presence continues

to grow. And throughout it all, one thing has become readily apparent: it's all about people.

In whatever we write about, there's always a human element of sorts. There are the obvious profiles on city-builders, movers, and shapers, but there are also posts about business, fashion, architecture, events, music, and the arts, all of which are driven by individuals. Less obvious is the fact that the stories about Vancouver's pristine natural environment are also about the people who had the foresight not to destroy it. Every one of our articles has humanity built into it, whether or not we say it up front—and besides, PeopleWhoMakeVancouverWhatItIsAreAwesome.com just doesn't have the same ring to it.

Three years ago, when Lani Russwurm agreed to contribute a weekly feature highlighting different aspects of the history of Vancouver, this whole "people" idea wasn't front-of-mind. But as Lani's column, entitled *Vancouver WAS Awesome*, began to take shape, and he started profiling some of the city's odder (or more notable, depending on who you ask) characters, it became apparent that Vancouver's most interesting history lies within the culture that buzzes in and around the built form and what has been, and what continues to be, built here.

We work closely with the Vancouver Heritage Foundation, which is also interested in Vancouver's past, being dedicated to preserving and restoring our city's built forms. Their work is incredibly important in ensuring that Vancouver's heritage buildings, which comprise some of the city's most important visual history, don't disappear. But while some local

historians tend to focus on physical buildings, it's the marriage of storeys and *stories* that reminds us of where we've been and where we're heading. In choosing to live in a city, especially one as young as Vancouver, we should not only expect constant change, but embrace it in all its forms, built or otherwise.

My friend Rick Antonson, president and CEO of Tourism Vancouver, recently introduced me to the idea of cathedral thinking. In his words, "Like cathedrals, world cities aren't formed overnight. Shaping Vancouver into a world city will take a lot of work—work based on a vision beyond our own times." The work we do at *Vancouver Is Awesome* is slightly different than Tourism Vancouver's in that we're thinking of our city and what it means to its *residents*, not tourists. But what makes Vancouver special to those who live and work here is certainly very closely tied to what draws visitors here from around the world, including those who choose to invest in it. The city is a work in progress, and we residents are the planners of its future, even if we won't live to see the results. In our own ways, we are all working to make this city a place that our children's children's children will proudly call home.

On the other hand, in the ephemeral world of online publishing, our six years of existence (as of this writing) already qualifies *Vancouver Is Awesome* as a grandfather of sorts. The world's first official online blog appeared in 1994, so we can't exactly claim pioneer status, but still, we've been around for about one-third of the time that the platform has existed. If you take that amount of time and apply it to the period since Vancouver's first European settlers arrived here in 1862—about 150 years—that makes us the equivalent of about fifty years old, comparatively. I know that might be some weird math, but what better time to release a history book than on our imaginary fiftieth birthday?

As we celebrate this "birthday," and as I prepare to toast Lani and his work putting together this fantastic book, I feel that I should also apologize for the use of the slightly misleading "Was" in the title: I'm sorry, that is, that this book doesn't contain harsh critiques of Vancouver, or begrudge what is versus what could have been; I'm sorry that it is not full of expert opinions on what has gone woefully wrong with our fair city, or how we're teetering on the edge of an urban-development cliff. I would also like to apologize for its utter lack of random and bitter longings for what we wish our city were, or could become. This book is, simply put, a celebration of the things that have made our city interesting from a historical perspective. Vancouver is, and will always be, *awesome*, especially as you and other Vancouverites continue to make it that way.

Deal with it.

—*Bob Kronbauer*
President and Editor-in-Chief,
Vancouver Is Awesome

INTRODUCTION
Vancouver History is Awesome

LIKE MANY VANCOUVERITES, THIS city is my adopted home. Learning about its past is a way to make sense of it, which, in turn, makes it feel more like home. On this personal level, local history is a little like genealogy: most of it may not have far-reaching consequences or be of global proportions, but I'm fascinated by how my little corner of the world came to be the way it is. At the same time, local history is not disconnected from global events. How the Great Depression or World War II, for example, were experienced locally can tell us something not only about Vancouver, but also about those international events because it is the human experience of something at a specific time and place that gives it meaning. Conversely, the broader national or global context is what makes a local history not just a chronology of a particular place, but also a story of how that place relates to the rest of the world. With a city as young and cosmopolitan as Vancouver, the relationship between the global and local is indeed a prominent part of its story.

City histories are traditionally stories of urban development, concerned with the evolution of land uses, civic institutions, transportation, and other infrastructure, along with notable events and changes in demographics and society. In Vancouver's case, this is the "milltown to metropolis" narrative that was first penned by Alan Morley in 1961.[1] *Vancouver Was Awesome* acknowledges and builds off that narrative but is primarily focused on the cultural history of the city. More precisely, what follows are mainly cultural micro-histories from the arts, entertainment,

sports, and various subcultures. The book's format of discrete images and stories allows for the inclusion of fleeting or offbeat historical tidbits that wouldn't fit very well into a more cohesive or linear narrative history, but which are nonetheless compelling and rightfully belong somewhere in Vancouver's local lore.

The advent of social history in the 1960s and '70s and, more recently, postmodernism and environmental history, have dramatically expanded notions of what subjects properly belong in a history book. Few historians today would attempt to cram a comprehensive account of something as big and complicated as an entire city between the covers of a single book. Chuck Davis's impressive *History of Metropolitan Vancouver* (2011) comes close, but is a compendium rather than a traditional historical narrative. More typically, urban historians prefer to focus on a single, more manageable, aspect of a city, such as a neighbourhood, a biography, or a notable episode. *Vancouver Was Awesome* draws from these various sides of the city to get a taste of its cultural life over the years. The city's diversity is reflected in these pages, but the reader should bear in mind that this book isn't proportionately representative of the numerous racial, ethnic, and other groups that have shaped Vancouver. First Nations, for example, have been far more significant to the area's history than what is contained here, whereas the city's black history is over-represented relative to population.[2]

Vancouver Was Awesome takes a mix-tape approach to history, covering a range of stories and images intended to stimulate an appetite for the city's history.

Just as there are only so many songs that fit on a sixty-minute cassette tape, not every person or incident that has contributed to Vancouver's awesomeness fits between the covers of a single book. The selection of stories or topics may therefore seem somewhat random and subjective—and to some extent this is true. But like a mix tape, to stretch the metaphor just a little, *Vancouver Was Awesome* is a sampler that includes a few greatest hits, some B-sides, and some rare tracks from before it was famous, such as Charles "Dad" Quick, a centenarian Powell Street saddle-maker who once helped build the first sewing machines, and Jimmy, the Stanley Park squirrel who, for some unknown reason, became so angry that he used his sharp little teeth to send several park visitors to the hospital. Whether it's a snapshot from a bygone era or outsiders creatively making the best of less-than-ideal circumstances, each of these stories concerns something or someone that has contributed to the overarching story of Vancouver.

Vancouver is Canada's big city on the West Coast, the largest in British Columbia, and the third largest in the country. Metro Vancouver is home to about two million people, and Vancouver proper has just over 600,000. This means it's a lot smaller than many big cities in North America. At just over 125 years old, it is also much younger than most big cities, although people have been living in the area for thousands of years. Vancouver's role as host city for big international events such as the 1954 British Empire and Commonwealth Games, Expo 86, and the 2010 Winter Olympics may very well qualify it as a "global city," as city boosters like to say. On the other hand, let's admit that it's no Paris or New York (which is not necessarily a bad thing).

More than anything else, people are what make Vancouver awesome. They are members of the Squamish, Musqueam, and Tsleil-Waututh nations who have occupied the area for millennia, the descendants of immigrants, and recent arrivals. Some residents live in ethnic enclaves such as Chinatown or Punjabi Market, and others reside where their finances permit regardless of cultural affiliations. Several waves of immigrants have acted as a major force of change throughout the city's history, generating, at times, social conflict and even riots. Yet for the most part, and throughout its history, Vancouverites from a variety of backgrounds have worked, lived, and played together around shared goals and interests, despite or maybe because of their differences.

Huddled on a peninsula bounded by Burrard Inlet, the Georgia Strait, and the Fraser River, Vancouver's natural setting is undoubtedly its most prized attribute. The weather is mild, the range of outdoor sporting activities year-round is impressive, and the vistas are spectacular. The seemingly constant rain is a common complaint, but optimistic Vancouverites prefer to think of it as "liquid sunshine" and praise the clean air, lush foliage, and other benefits of living in "Raincity," a nickname Vancouver shares with nearby Seattle.

Stanley Park, a thousand-acre (four square km) green oasis in the centre of the city, is a top attraction for visitors and locals alike. It differs from other big-city parks in that much of it is forested rather than landscaped, giving visitors a sense of what Vancouver was like before the city was built. At the same time, Stanley Park offers ample facilities that make it user-friendly, including a seawall for cyclists and pedestrians, sports fields, the Vancouver Aquarium, several restaurants, supervised public beaches, an outdoor swimming pool, and the iconic Lions Gate Bridge. An

army of park employees ensure that the grounds are maintained, new trees are planted, and that park visitors are protected from the more menacing aspects of nature.

Because it is such a young city, Vancouver's identity apparently remains a work in progress. It has been called many things—Terminal City, Lotusland, Vansterdam, City of Glass—but none of its nicknames fully captures its essence. That may be less a sign of immaturity than an indication that Vancouver's persistent characteristics are too contradictory to fit into a single, unified urban identity. It is young and ancient, big and small, a "left coast" city that votes right-of-centre governments into office more often than not. Vancouver wears its cultural diversity on its sleeve, yet minority groups still encounter discrimination. It's a prosperous city encompassing one of the poorest urban neighbourhoods in Canada. Vancouver's natural environment is conducive to healthy and active lifestyles, but since its earliest days the city has had a pronounced and often destructive relationship with mind-altering substances with which few other places in Canada could compete.[3] Vancouverites have always valued their city's natural endowments but have nevertheless felt the need to alter the landscape, even Stanley Park, so drastically over the years that a time traveller from a century ago would find little that was familiar in the city today. (Vancouverites have resisted, however, innumerable development proposals for the park, including a massive sports complex and a Jurassic Park-type attraction of giant robot dinosaurs, and have attempted to minimize the transformative effects of nature on the park.[4])

Vancouver's persistent contradictions are largely a result of its historical development. The arrival of the Canadian Pacific Railway (CPR) in the 1880s was key to Vancouver's early growth. Its corporate interests often diverged from those of the less powerful businesses and communities that were already here, creating a dynamic resulting in differences still seen, for example, between the east side and the wealthier west side of the city that developed on CPR land. The transcontinental railroad was a nation-building project intended to unify Canada, a pre-condition to British Columbia joining confederation that would facilitate the movement of goods and people on an east-west axis. Indeed, the colony of British Columbia was formed as a bulwark against annexation by the United States when Americans began flooding into the gold fields in the north. By the early twentieth century, Vancouver was unquestionably a British Empire town and a majority of Vancouverites were either British or traced their ancestry to Great Britain.

The fortunes of early Vancouver were nevertheless tied to those of other major centres down the coast. Hastings Mill, the city's largest industry at the time of incorporation, was owned by San Franciscans and was a major supplier of lumber to the building boom triggered by the California Gold Rush.[5] The arrival of the CPR in 1887 didn't stop the flow of people and goods across the border; loggers and other itinerant resource workers drifted around the Pacific Northwest to wherever the work was to be had. Vaudeville circuits ensured a steady flow of Americans, as did the Klondike Gold Rush at the end of the nineteenth century.[6] Sex trade workers (including prostitutes, madams, and piano players—who were considered "inmates of bawdy houses") were run out of US cities and came to Vancouver because of its predominantly male population in the early days. Vancouver began as a product of both the British Empire in the

Victorian Era and the (North) American Old West. It has much history in common with Pacific Coast cities such as Seattle and San Francisco that it doesn't share with other Canadian cities. In more recent years, Asia has had an influence on Vancouver's local culture through immigration and increased economic linkages.

The circumstances in which Vancouver was founded contributed to its dynamic character. While other British Columbia settlements, such as Victoria and Barkerville, grew somewhat haphazardly into bustling centres almost overnight as a result of the province's gold rushes, Vancouver was chosen to be the terminus of the transcontinental railroad. It was destined to become a major city, making it a magnet for people looking for new opportunities, be they wealthy investors, entrepreneurs, discouraged gold miners, or confidence men. As a "city of destiny," Vancouver was always meant to somehow be bigger and better than it is, implying that it will keep growing and changing until it reaches its full potential.[7] Actual growth and development has ebbed and flowed over the years, but the idea that Vancouver *should* grow and change has more or less prevailed throughout its history. The counterpoint to constant change is the impulse of Vancouverites to preserve their city's features that are already pretty awesome.

Of course, Vancouver's history hasn't been all positive, and the contradictions described above have generated conflict as well as constructive changes. The ongoing legacies of colonialism and racism have filled the pages of many a local history book. *Vancouver Was Awesome* consists of positive stories that helped make the city what it is, but in many cases, the context—whether racism, war, or economic depression—was anything but positive. The

story of longshoreman Chief Joe Capilano, bringing the grievances of BC's First Nations to the King of England in 1906, for example, is inspiring even if the reasons behind those grievances are abhorrent. And Vancouver's history also belongs to, for example, the Asians who historically endured harsh racism here and whose stories show tenacity, perseverance, and a dogged determination to make the best of the situation in which they found themselves. Their history includes tales of remarkable bravery and creativity in resisting and trying to overcome racial oppression.

Sometimes seemingly trivial or mildly amusing stories can do more than just entertain us; they can enlighten us about life in the city at a certain point in time and tell us something about ourselves by contrasting our own preoccupations with those of the people who came before. In 1911, news stories reported on a cougar in Stanley Park that was killing zoo animals. The *Province* newspaper used the story to suggest that Vancouver men, who had failed to find and kill the cougar, had become soft from city living, and so the task was left to more manly hunters brought in from Cloverdale. It's not difficult to imagine that such an incident, if reported today, would play out and be interpreted quite differently, given that cities are not considered emasculating as they were a century ago, and the influence of environmentalism on how we understand our relationship with nature. Today, there are no longer zoo animals in Stanley Park for cougars to munch on—or cougars, for that matter.

Local histories can also challenge our assumptions about specific periods in the past. For example, our assumptions about the prohibition era may have been at least partially shaped by the American experience, with its bloody gang wars and the FBI's subsequent

"war on crime" that shook cities like Chicago. In contrast, the law that brought prohibition to Vancouver was so weak that a Chicagoan living here in 1919 later recalled that there "was no Prohibition in British Columbia, but the liquor laws were so complicated that Vancouver was what we called a dry town."[8] In other words, people simply drank alcohol in private homes instead of licensed establishments or gangster-run speakeasies (although many private homes operated as speakeasies).

Several topics highlighted in this volume have been neglected in Vancouver's historiography, in part because available primary sources privilege some topics while ignoring others. One example in this collection is the history of Vancouver's short-lived "hot jazz" scene during the prohibition era. Music historian Mark Miller discovered it while researching his book *Such Melodious Racket*—not through Vancouver sources, but in an African-American newspaper called the *Chicago Defender*. Black performers travelling on entertainment circuits used the paper as a sort of social-networking tool, no doubt to compensate for the utter lack of coverage of black culture in white-owned and operated papers. Vancouver correspondents were often black railway porters or entertainers on the road who gave readers tips on where to stay and which jazz clubs to check out. From this perspective, Granville Street was beginning to resemble a miniature version of Chicago's famed jazz strip, and Vancouver's Patricia Cabaret was one of the most happening clubs in the Pacific Northwest. If not for a handful of mentions in the *Defender* and in the recollections of two jazz musicians, this fascinating local cultural scene may well have been entirely forgotten.[9]

Contemporary racism only partially explains why Vancouver's jazz age went almost entirely undocumented. In the early decades of the twentieth century, conceptions of bona fide "culture" in the city were limited to classical European arts, while vaudeville was the main form of popular live entertainment. Cultural streams, however rich, that fell outside of these two categories were typically marginalized and often dismissed. Ironically, subcultures ignored by the media were often free from the scrutiny of, and constraints imposed by, the self-appointed arbiters of culture. Vancouver's early jazz scene was therefore able to flourish, however briefly, outside of mainstream culture. Another reason for the lack of documentation is simply that people at the time didn't know that jazz would develop into something widely considered culturally significant.

Several of the following stories concern awesome people who were just passing through Vancouver or whose connection to the city was short-lived or at best tenuous. These outsider perspectives offer an interesting take on the city at a specific moment in time. When Charlie Chaplin came here in 1911 and 1912, he felt Vancouver was just another English town, which says something about how dominant the English were demographically, in popular culture, and even in the accents heard on the street. Chaplin is just one of the celebrities to appear in this book, which has more to do with sources than any fondness for celebrities on my part. For fame is one way that otherwise ordinary people leave a trail of documents that enable historians to learn about a city. If not for Loretta Lynn's fame, the little country music scene where she was discovered in Vancouver's Fraserview neighbourhood might well have been lost and forgotten. And Jimi Hendrix's fame has turned out to be an important vehicle for learning about Vancouver's black history through interviews with

his Vancouver-based grandmother and in a book by his father in which he describes what it was like for a black kid growing up in Vancouver before World War II.[10]

A number of entries in this book are sports-related. Sports have always been a big part of local popular culture that reveal much about the city and broader culture, especially from the days when "millionaire" was more likely to be the name of an athlete's team than the status of his bank account.[11] Participation in sports often allowed people to shine despite their social status or circumstances—or even physical stature, as in the cases of Tommy Burns, the five-foot, seven-inch (171-cm) former world heavyweight boxing champion, and the spindly and sickly five-foot, six-inch (168-cm) runner Percy Williams, who was nevertheless an Olympic gold medalist. Sports offered a means to both fans and athletes to influence or temporarily escape the rules of a society that privileged some at the expense of others for neither their merit nor abilities.

Ultimately, what many of the following micro-histories show is that attempts to nail down a particular conception of what Vancouver and its culture should be were frequently challenged, undermined, or ignored—with some intriguing results. Animals ignored expectations about how they were supposed to behave, Natives failed to act like the primitive remnants of a dying culture, and marginalized people refused to stay on the margins. Most of these stories in some way reflect the many contradictions on which Vancouver was built and which established patterns that can still be seen playing out today. Collectively, these stories are irrefutable proof that Vancouver history is, well, awesome.

Vancouver Was Awesome is organized chronologically and divided into three chapters. Chapter One takes us from pre-incorporation in 1886 to 1910, before Vancouver was a city in any meaningful sense of the term. It took years for its infrastructure and the institutions of law, order, politics, and civil society to develop. In the meantime, Vancouver was more of a patchwork of neighbourhoods, squatter colonies, and First Nations and other communities than a unified city. The second chapter begins in 1911, the year the population surpassed 100,000, making Vancouver a city in fact, not just ambition. Although its urban foundations were now firmly in place, Vancouver's development was anything but smooth in a period that included the disruptive and transformative World War I and the Great Depression. The turmoil created by these events, however, made this a very creative era as people sought new ways of doing things. The final chapter begins in the 1940s, when the modern city we know today starts to become recognizable. World War II brought an abrupt halt to the Great Depression and ushered in the dramatic economic boom that followed the war. The other boom in this period was the Baby Boom that made subsequent decades notably youth-centric. *Vancouver Was Awesome* ends in the early 1970s with a fight over a proposed freeway network that would have demolished some of the oldest sections of the city. Spirited debates and protests around urban planning did not end with the freeway fight, but it did mark a sea change in how political decisions are made in Vancouver.

Key to abbreviations in image credits

BCA British Columbia Archives

CLGA Canadian Lesbian and Gay Archives

CVA City of Vancouver Archives

CBC Canadian Broadcasting Corporation

LAC Library and Archives Canada

LoC Library of Congress

NPG National Portrait Gallery

UBC University of British Columbia

VPL Vancouver Public Library

1 Alan Morley, *Vancouver: From Milltown to Metropolis* (Vancouver: Mitchell Press, 1961).

2 The July 19, 1952 edition of the *Vancouver Sun* estimated Vancouver's black population to be 700. Current estimates put the figure around 20,000, still a small number for a city the size of Vancouver. Wayde Compton, "Black History in Vancouver Recognized At Last: The Hogan's Alley Memorial Project," *Rabble.ca*, accessed July 5, 2013, http://rabble.ca/news/2013/02/black-history-vancouver-recognized-last-hogans-alley-memorial-project.

3 Vancouver's illicit drug scene inspired Canada's first drug prohibition laws, and the city has had proportionately and at times absolutely more illicit drug users than other cities in Canada for much of its history. See Catherine Carstairs, *Jailed for Possession: Illegal Drug Use, Regulation, and Power in Canada, 1920–1961* (Toronto: University of Toronto Press, 2006).

4 The best example of minimizing the effects of nature on Stanley Park is the response to major storms in the 1930s, 1960s, and 2000s. All three storms were followed by civic campaigns to raise funds, public support, and political will to "restore" the park as much as possible to its pre-storm state.

5 Robert A.J. Macdonald, *Making Vancouver: Class, Status, and Social Boundaries, 1863–1913* (Vancouver: UBC Press, 1996), 7–8.

6 Gold seekers stopped to get outfitted in Vancouver on their way up north and many settled here after failing to make their fortunes in the Klondike. The most well-known of this group is L.D. Taylor, a Chicagoan whom Vancouverites elected as their mayor more times than anyone before or since.

7 The term "City of Destiny" was popularized in a political speech by Mayor G.G. McGeer in the 1930s. See David Ricardo Williams, *Mayor Gerry: The Remarkable Gerald Grattan McGeer* (Vancouver: Douglas & McIntyre, 1986), 167.

8 Bricktop with James Haskins, *Bricktop* (New York: Welcome Rain, 2000), 71.

9 Ibid., and Alan Lomax, *Mister Jelly Roll: The Fortunes of Jelly Roll Morton, New Orleans Creole and "Inventor of Jazz"* (Berkeley, CA: University of California Press, 1973).

10 James "Al" Hendrix, *My Son Jimi* (Seattle: Aljas Enterprises, 1999).

11 The Vancouver Millionaires were a professional hockey team from 1911–26, a time when professional athletes had to have other jobs during the off-season in order to make a decent living.

CHAPTER ONE
The Wild Old West: 1910 & Earlier

AT THE TIME OF ITS incorporation in 1886, Vancouver was a patchwork of small, pre-existing communities. Archaeological evidence from the Gulf of Georgia Cannery site on the south shore of the Fraser River indicates that First Nations have occupied the area for at least 9,000 years. Musqueam and Squamish communities were well-established long before any Europeans arrived. The Musqueam Nation has occupied the shores around the mouth of the Fraser River for at least 3,000 years, while Squamish settlements were around Burrard Inlet. Off the peninsula, the Tsleil-Waututh Nation is based on the north shore of the inlet. All three nations belong to the Coast Salish language and ethnic group, and facilitated diplomatic relations with one another through potlatches and intermarriage and sharing the abundant natural resources of the area.

In what later became known as Stanley Park, there was Chaythoos, east of Prospect Point, and the village of Xway'xway was located where Lumberman's Arch is today. Brockton Point was home to a mixed group of Natives, Kanakas (Pacific Islanders), Portuguese, Chinese, and others. Senakw was a small Native village on the south side of False Creek where Burrard Bridge now stands, and there was a Musqueam village to the west of Jericho Beach.[12] The sandbar that is now Granville Island was used by Native fishers. Potlatches were major social gatherings that attracted thousands of people.[13] Large longhouses helped accommodate these events, which featured music, dancing, and the giving away of blankets, canoes, and later, guns and other goods acquired

from settlers. As most of the area around Vancouver was dense forest, these communities were situated on the waterfronts of English Bay, Burrard Inlet, False Creek, and the Fraser River. Canoeing was the best way of getting from place to place.

1 *Squamish dwelling at Lost Lagoon in Stanley Park, 1868, CVA #St Pk N4*

Gastown emerged as the commercial centre of the area and was officially christened "Granville Townsite" in 1870. Although it was dominated by Englishmen, early Gastown was a culturally mixed community that included "Gassy" Jack's Native wife and son, a black family who ran a general store (Sullivan's), and a Chinese family who operated the Wah Chong laundry on Water Street. At the foot of Dunlevy Avenue, Hastings Mill was the industrial basis for the nascent city of Vancouver. Native mill workers lived in a "rancherie," a cluster of cabins at the foot of

Campbell Avenue, at least until the Canadian Pacific Railway (CPR) cleared it out to make way for its train in 1887. To the east, Hastings Townsite at the Second Narrows was a separate settlement that, in the early days, served as a resort town for people from New Westminster; it didn't become part of Vancouver until 1911. Clusters of shacks and later, houseboats, lined the shores of Deadman's Island, Coal Harbour, and elsewhere along False Creek and Burrard Inlet from the mid-1800s until they were all gradually cleared away as illegal squatter colonies. A group of entrepreneurs known as the "Three Greenhorns" attempted to develop what is now the West End, which they dubbed "New Liverpool," but they ended up selling the land to the CPR. Jerry Rogers operated a bustling logging operation at what is now Jericho Beach, and he cleared the forest from much of the west side of the city. Fitzgerald McCleery, his brother Samuel, and his uncle Hugh McRoberts started a farm on the North Arm of the Fraser River in the 1860s and others soon followed suit. In the 1880s, Sam Greer set up a farm on what's now Kitsilano Beach.

When the CPR arrived just one year after the city's incorporation, the commercial heart of Vancouver was already established around Cordova, Carrall, and Water Streets, but the company quickly set to work

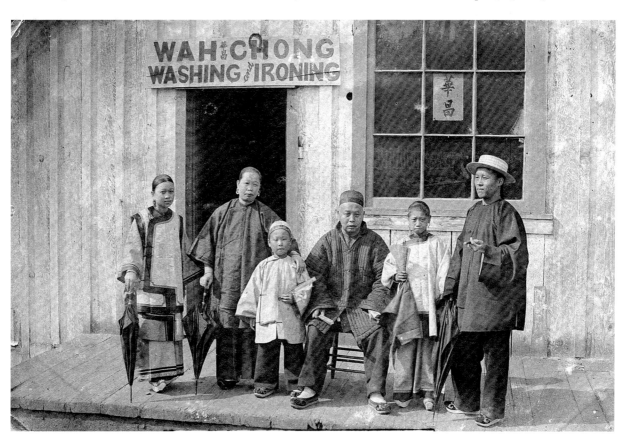

2 *The Wah Chong family's laundry business in Gastown, 1884, CVA #178-2-8*

developing its own huge parcel of land on the western portion of the peninsula. As a nod to the old town site that Vancouver had replaced, the CPR designated Granville Street as the main commercial corridor of its portion of town. Anchored by its passenger terminal on the waterfront, the CPR built the (relatively) lavish Hotel Vancouver and the Vancouver Opera House in the late 1880s on Granville at Georgia Street, where the biggest trees in the area once grew. A gazebo was erected on the northwest corner lot to make CPR Park, which hosted big outdoor festivals.

Despite the CPR's major influence, it did not have a monopoly on the cultural life of the city. A resident of the Sunny Side Hotel on Water Street remembered climbing the walls of the CPR's partially built Vancouver Opera House in 1888 to watch horse races on Howe Street between Nelson and Georgia.[14] The Imperial Opera House on Pender was built around the same time as the CPR's much fancier one. F.W. Hart's Opera House on Carrall Street predated the other two, though it was the opposite of fancy. The building, which began life as a roller rink in Port Moody before being transported across the inlet, had a canvas roof, dirt floors, and burlap-lined walls, but big-name touring acts from around North America and Europe played there to full houses.[15] The powerful and wealthy CPR and the older, more organically developed communities coexisted in early Vancouver, creating a dynamic that would persist through the years in terms of determining the city's social and cultural landscape.

Business interests led by David and Isaac Oppenheimer fought the CPR to keep the business centre in the East End, but acquiesced after a struggle over the location of the new post office. The CPR's preferred location at Hastings and Granville won out; the post office building is now part of the Sinclair Centre mall.[16] The wealthiest Vancouverites were quick to establish their own exclusive neighbourhoods, first on the bluffs overlooking Coal Harbour, then in the West End and Shaughnessy Heights. A few neighbourhoods in the East End, such as Chinatown and Japantown, had meanwhile become enclaves for non-British immigrants; these areas facilitated mutual aid and the provision of social services within those communities and helped to soften the impact of racial and cultural discrimination.

The development boom that began in early 1886 ended with the depression of the 1890s, but the Klondike Gold Rush provided welcome relief to the city, as gold seekers flowed through Vancouver and spent their savings getting outfitted for the gold fields. Some saw that there were better opportunities to be had within the rapidly growing city, and others later returned to settle in Vancouver after failing to strike it rich in the Klondike. At the dawn of the twentieth century, Vancouver was still small, but it was beginning to resemble larger and more established cities, with substantial brick buildings, relatively defined neighbourhoods, social institutions, bridges, street cars, and other urban infrastructure.

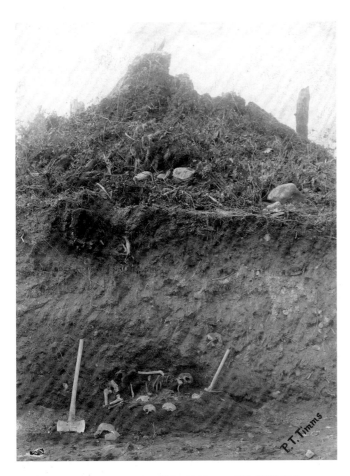

3 *Great Fraser Midden, 1908, Philip T. Timms, CVA #677-521*

GREAT FRASER MIDDEN

The Great Fraser Midden (a.k.a. the Marpole Midden) was revealed in 1884 during road construction on the site of an ancient Musqueam village on the Fraser River called c̓əsna?əm (pronounced cusnaum). Shell middens typically consist of layers of seashells mixed with animal bones, implements, art, and a range of other cultural objects, and are essentially ancient refuse dumps. Because shells are alkaline, the contents of middens are usually well-preserved and therefore valuable historical records of the societies that created them.[17]

This midden turned out to be a major discovery because of its age and exceptional size; at three-and-a-half acres (14,164 sq. metres), it is much larger than others found in Vancouver. It is up to fifteen feet (4.58 metres) deep in some places, making it a treasure trove of archaeological artifacts. It also served as a burial site for the c̓əsna?əm villagers, who occupied the site from over 3,000 years ago until they were decimated by smallpox in the nineteenth century, so its rediscovery was critical for re-connecting the Musqueam with their ancestors who lived there.[18]

The centre of the midden is in what's now the parking lot of the old Fraser Arms Hotel, owned by the Musqueam. Although numerous artifacts, skulls, and other remains have already been pillaged by collectors, museums, and archaeologists since the late 1800s, much of the site remains intact. In 2012, members of the Musqueam First Nation successfully blocked a condo development that threatened to destroy and desecrate one of the most significant archaeological sites in Canada.[19]

Other middens have been found in Vancouver, indicating a long human history on the peninsula, including one in Stanley Park that was destroyed to make the road around the park and another that remains unexcavated beneath the Casa Mia mansion in Kerrisdale.[20]

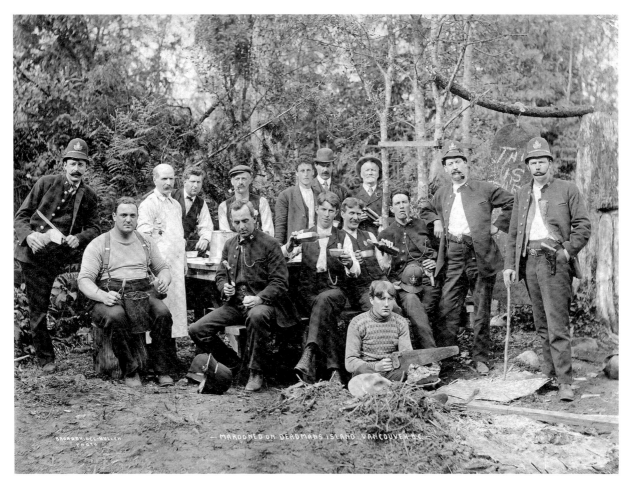

4 *Police on Deadman's Island, 1913, Bullen-Broadbridge, CVA #St Pk P330*

DEADMAN'S ISLAND

Deadman's Island has been the home of HMCS Discovery Naval Reserve since World War II, but its martial history goes back much further. The death and conflict associated with the island isn't exactly awesome, but it shows that this area's history is anything but boring.

Drawing from a legend told to her by Chief Joe Capilano, Pauline Johnson wrote about a massacre during a war between First Nations from the north and the south. The faction from the south captured their enemy's women and children and

threatened to kill them unless the best warriors from the northern tribe agreed to take their places in a one-for-one trade. Two hundred brave warriors accepted the terms and submitted to be slaughtered. The women and children captives were freed and, according to the legend, awoke the next morning to find a field of fire-flowers where their warriors had fallen. "Deadman's Island always mean fight for someone," Capilano explained.[21]

Another conflict played out on Deadman's Island between 1899 and 1911. When industrialist Theodore Ludgate arrived there, the island was undeveloped except for a squatter colony along the shore. Ludgate persuaded the Dominion government to lease the island to him so he could build a sawmill. The city objected, claiming it was part of the military reserve parcel that the Dominion leased indefinitely to Vancouver for

Stanley Park. Ludgate replied by saying if the police tried to stop him, they would be trespassing and "it would be a sorry day for Vancouver."[22] Mayor James Garden arrived on the island the very next morning with a few dozen police. After Ludgate picked up an axe and began chopping down trees, he and his crew were arrested.[23] Ludgate resigned himself to continuing the battle in the courts.

The Privy Council finally ruled on the case in 1911 in Ludgate's favour, and the police contingent who had been guarding the island since 1909 was reassigned. Ludgate cleared all the trees off the island, but by then his company had gone bust, and the sawmill plan never got off the ground.[24] The now-barren island was left unused until the federal government took it back for use as a naval reserve during World War II.

5 *Deadman's Island, 1910s, J. Wood Laing, CVA #677-136*

GEORGE VANCOUVER

Explorer George Vancouver and his crew on the *Discovery* and *Chatham* arrived at the place destined to take his name on June 13, 1792. When they passed by Stanley Park, about fifty Natives in canoes paddled out to greet them, probably from Xway'xway. Vancouver wrote that the locals "conducted themselves with the greatest decorum, and civility, presenting us with several fish, cooked, and undressed."[25] He does not tell us what the Natives received in return, but was impressed at their sophistication in preferring iron over copper items. His crew was not having any

luck catching fish themselves, so the exchange was especially appreciated.[26]

Vancouver and most of his crew spent the night on the ships, but some of the fellows decided it would be a nice change to sleep outside on the rocky beach. Most of them were rudely awakened by the rising tide, except for one of them, who, Vancouver wrote, "slept so sound, that I believe he might have been conveyed to some distance, had he not been awakened by his companions."[27]

But the explorer's most significant discovery in the area caused him "no small degree of mortification"[28]: a couple of Spanish ships, which made him realize that he was not the first European to explore the area. Spanish Captain Dionisio Alcalá Galiano informed Vancouver that he and his crew were following up an expedition carried out the year before under Captain José María Narváez that marked the first European visit to the area.[29] Spanish Banks and English Bay were later named to commemorate this encounter.

Almost a century later, to the chagrin of some Vancouver, Washington residents, as well as those on Vancouver Island, Canadian Pacific Railway boss William Van Horne renamed Granville Townsite "Vancouver" in the 1880s, not because of the explorer's legacy here, but because its proximity to Vancouver Island would convey a sense of its location to those back in the motherland, whereas the generic "Granville" and even "British Columbia" could have been place names anywhere in the British Empire.[30]

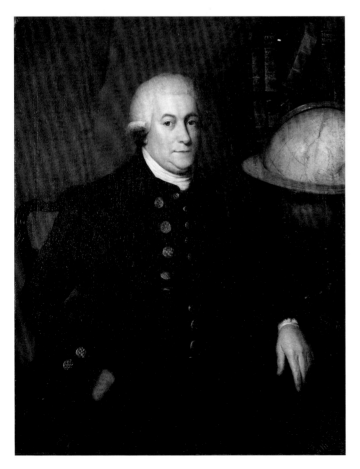

6 *George Vancouver (painted between 1796 and 1798), NPG #503*

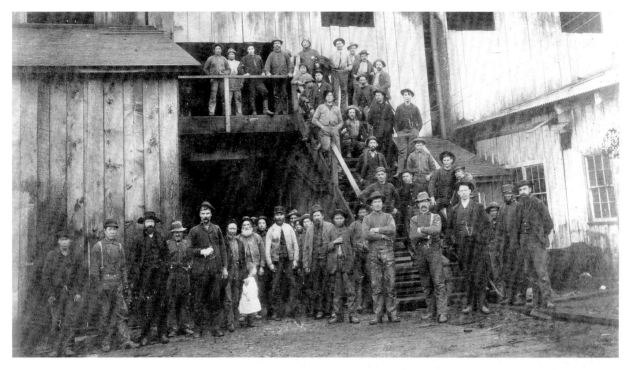

7 *Hastings Mill employees, ca. 1889, Charles S. Bailey, CVA #Mi P4*

8 *Hastings Mill wharf, 1886, Harry T. Devine, CVA #Mi P12*

HASTINGS MILL

Hastings Mill was the locus of the original non-Native settlement on Burrard Inlet. The mill was originally called Stamp's Mill after its founder, Captain Edward Stamp, and began operations in June 1867. In less than four years, it was insolvent and sold off to investors from London and San Francisco. By 1871, an Englishman named R.H. Alexander was managing the mill. Years later, Alexander reminisced about his early days on Burrard Inlet and the hybrid trading language used by mill employees: "Our mill hands were very largely composed of runaway sailors and Indians, of whom there was a rancherie located on the shore about where Heatley Avenue wharf is. Everyone in these days understood and spoke Chinook; selling whiskey to Indians was a somewhat common offence, and in such cases, as

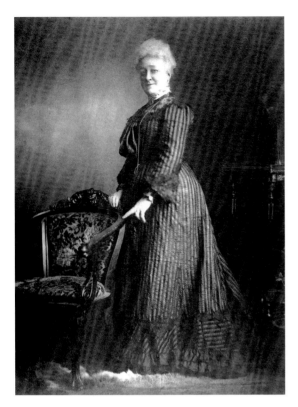

9 *Mrs Richard Henry Alexander, ca. 1875, BCA #A-09240*

EMMA ALEXANDER

Emma Alexander was the wife of Hastings Mill manager R.H. Alexander. As the first lady of the mill settlement, Mrs Alexander took a leading role in the social life of the area. She helped organize and participate in events such as the Dominion Day celebrations, the major social event of the year at the mill, which featured music and sports and drew hundreds of participants from as far away as New Westminster. She also saved the day on at least two occasions.

According to one pioneer, Mrs Alexander single-handedly prevented a race riot in the days just before Vancouver's incorporation. A crowd of boisterous workers recently laid off from CPR construction sites came "tramping and shouting" through Gastown on their way to the Chinese shacks east of the mill at the foot of Dunlevy Street. Hearing the ruckus, Mrs Alexander "was fearless and went out with her apron on—she wore a big white apron—and … reprimanded them severely." Apparently that was enough to make the mob disperse.[33]

During Vancouver's Great Fire in June 1886, Mrs Alexander again proved her mettle, "with a boldness with which few are capable," when she doggedly led the effort to save her home and the mill from destruction while her husband was away.[34] Thanks to her, the Hastings Mill Store (built in 1865 and relocated to the foot of Alma in 1930) has survived to become Vancouver's oldest extant building.

everyone concerned understood Chinook, the proceedings of the Court were often carried on in that jargon to save the trouble of interpretation."[31]

Alexander was the leading contender in Vancouver's first mayoral election. Unfortunately for him, Vancouver's first labour strike was then underway at Hastings Mill. The strikers were mostly British-born navvies fighting to have their twelve-hour work day reduced to ten hours. Alexander wouldn't budge and offended the strikers by saying he could hire more Chinese workers, and that the strikers were just "North American Chinamen" anyway. Despite being well connected and favoured to become Vancouver's first mayor, Alexander's handling of the strike likely tipped the balance in favour of real estate broker Malcolm Alexander MacLean.[32]

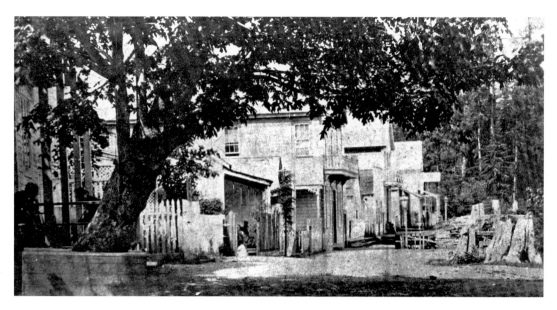

10 *Gastown showing Deighton House (far left), ca. 1880, Joseph Davis, CVA #Dist P11.1*

GASSY JACK

John Deighton, better known as "Gassy Jack" because of his chatty nature, was a sailor turned saloon keeper when he saw a business opportunity on Burrard Inlet. He knew there was a demand for a place to drink because he witnessed workers from the boats and Moodyville Sawmill on the North Shore make the long trek to his Globe Saloon in New Westminster.

Deighton was ill in the summer of 1867, so he took a therapeutic trip to what's now Harrison Hot Springs and left an American friend in charge of the saloon. To celebrate the Fourth of July, the "friend" blew all of the Globe's cash on fireworks and gunpowder and gave away booze all day. When Deighton returned to find that he was broke, he decided to make the move to Burrard Inlet, where Captain Edward Stamp had just begun production in his new sawmill.

Deighton and his Native wife arrived in a boat with little more than a barrel of whiskey.

According to legend, he offered to share his booze with a crew of locals if they helped him build a saloon. The new Globe Saloon was up and running within twenty-four hours.[35]

Deighton's gamble paid off. As Stamp's and Moody's sawmills steadily increased production—and the movement of lumber and thirsty workers through the harbour—the flow of drinkers to the Globe also increased. The saloon-keeper was able to replace his original shack with a proper two-storey establishment, the Deighton Hotel. After a while, he was joined by other entrepreneurs: "I was here a year and a half before anyone found out I was making money," he wrote to his brother. "Finally it was found out, and then a rush—hotels, saloons, stores, and everybody was going to make a pile and run me out, but they did not succeed, for I have done … most of the business."[36]

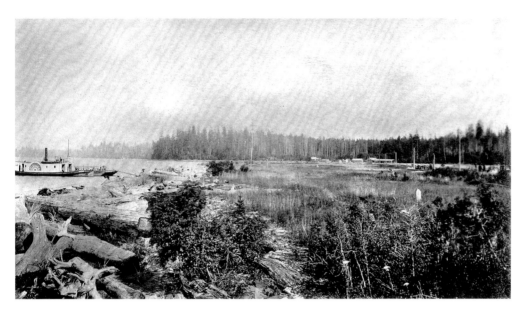

11 *Jericho tidal flats, ca. 1890, Bailey Bros., CVA #Be P41*

JERICHO BEACH

Jericho Beach was the site of a logging operation owned by Jeremiah Rogers and, at first, everyone referred to it as "Jerry's Cove." The first recorded use of the shortened "Jericho" was in 1872 following a gun battle involving Frank Shepley and William Brown, American pirates who "proved themselves a terror to residents of British Columbia."[37]

After Shepley and Brown stole several guns from one Mr Maud on Hornby Island, Maud tracked the duo to Burrard Inlet where he alerted Constable Jonathan Miller, Granville Townsite's lone police officer. A Mr Bridges also reported that the fugitives had tried to sell him a stolen boat. Miller recruited his predecessor, Tompkins Brew, as special constable. When the desperados got wind that the law was after them, they fled Hastings Mill for False Creek. The police caught up with them at Jerry's Cove. Shepley spotted Tompkins Brew and began shooting. Brew returned fire and then Constable Miller joined in. No one was hurt in the gunfight, but the freebooters escaped into the bush, leaving their boats and most of their loot behind.[38]

A correspondent in a Victoria newspaper criticized the police for failing to capture the fugitives. Brew responded with an indignant letter to the *Mainland Guardian*:

It was to be hoped the battle of Jerico [sic] would be forgotten, almost as soon as Gravelotte, or other comparatively insignificant engagements, but no—it is still the subject of comment by wiseacres, who think they would have done better than the Constables. When the Magistrates in New Westminster wanted Specials to hunt up Brown and Shepley, there was an excellent chance for some people to display their patriotism and valor by going. No doubt they would have done better than the Constables, and many people regret that some of them did not go. There would then be far less comment on the matter.[39]

Shepley and Brown left Burrard Inlet, but continued pillaging the coast despite the $250 reward for their capture, dead or alive.[40]

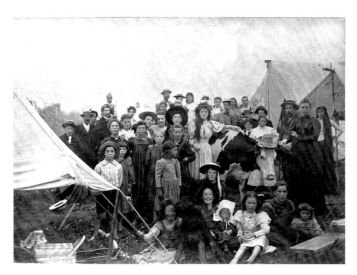

12 *A gathering at Greer's Beach, 1896, CVA #Be P98*

GREER'S BEACH

Vancouver's Kitsilano Beach was originally called Greer's Beach after Sam Greer, a homesteader who set up a seven-acre (28,328 sq. metre) farm at English Bay in June 1884. When the railway came to town, Greer was one of the numerous "squatters" it had to evict from the 6,000 acres (24 sq. km) the company had been granted as part of the deal to locate its western terminus at Burrard Inlet.[41]

Greer spent years fighting the CPR to keep his land, in court and mano-a-mano. Once he used an axe to chase off the officials who came to evict him,[42] and another time he was successfully evicted but managed to get an injunction allowing him to reoccupy the land and have the CPR's crew and equipment removed. Greer also erected barricades to prevent CPR construction on his property.[43]

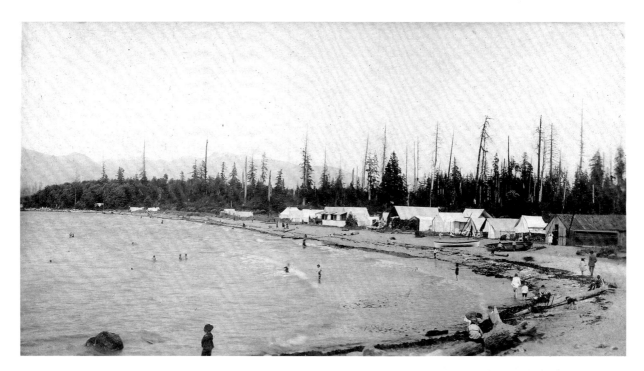

13 *Greer's Beach, 1900, CVA #Be P99*

The final showdown came in 1891, when the deputy sheriff and a gang of CPR men came to kick Greer and his family out and demolish his home and barn.[44] Greer ran into the house and slammed the door, through which he fired a round of buckshot that wounded the sheriff. A jury found that Greer had discharged his weapon accidentally. However, Judge Matthew Baillie Begbie browbeat the jury into finding him guilty of assault, and he was sent to prison.[45]

As a final insult, the CPR changed the beach's name to Kitsilano but left it undeveloped for years. In the meantime, it became an informal summer resort called "Tent Town" that got more popular each year, especially after a new streetcar line made it accessible in 1905. The informal campground was finally shut down in 1908 due to a lack of sanitation facilities, and the CPR opened it up for residential development in 1909.[46]

GREAT VANCOUVER FIRE

On June 13, 1886, the barely two-month-old City of Vancouver burned to the ground. It was a horrible tragedy: although the exact death toll is uncertain, it's estimated that more than twenty people lost their lives and thousands lost everything they owned. But it was a baptism by fire, and it spurred the ambitious project of building a substantial city. The rickety, hurriedly built wooden structures that had made up most of the city before the fire were now cleared out of the way. News of the blaze was carried in newspapers internationally, making it Vancouver's introduction to the world. Money flooded into the city in the form of relief, insurance claims, and investment for reconstruction. Within days, new structures began sprouting on the charred landscape.

Not everyone waited for the fire to run its course before making the best of a bad situation. A newspaper article syndicated in the *Toronto World* and *New York Times* described the revelry: "During the confusion which prevailed, when rowdies and roughs saw that every one [sic] was leaving, they entered the saloons which had been left entirely unprotected and commenced drinking.

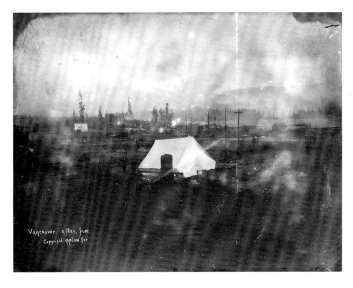

14 *Vancouver the day after the fire, 1886, H.T. Devine, CVA #LGN 455*

Many a one was seen staggering along the streets with a keg of beer on his shoulder and as many bottles of liquor as he could appropriate."[47]

Another witness described the "rough and wild crowd [that] held revelry ... Whiskey casks that had escaped the fire, by being rolled into the water, had been breached and the contents lent their maddening influence to the already over-excited crowd."[48] By the next day, the *Victoria Times* reported that "the rowdy element prevails at present, but Constable Huntly anticipates no serious trouble."[49]

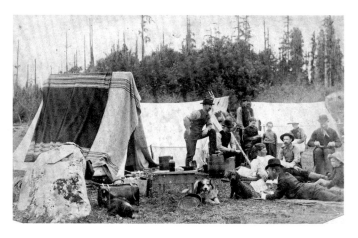

15 *Refugee bivouac the day after the fire, 1886, CVA #GF P6*

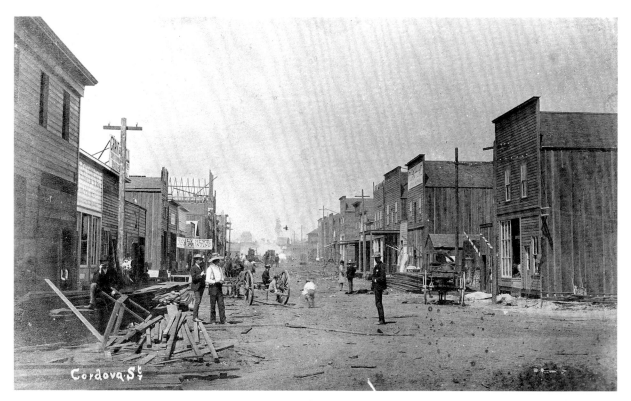

16 *Cordova Street five weeks after the fire, 1886, CVA #Str P7.1*

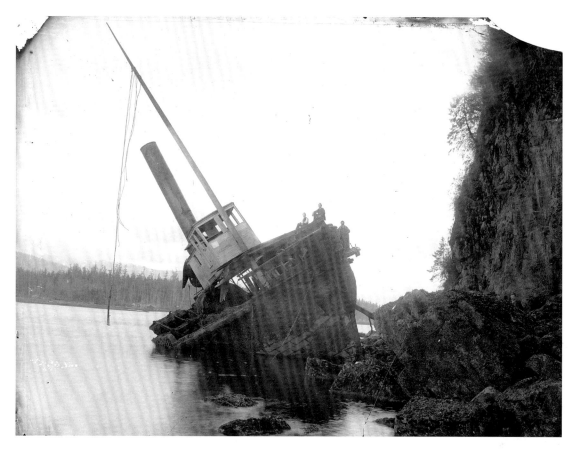

17 *The wreck of the Beaver, 1890s, Norman Caple, CVA #LGN 673*

THE WRECK OF THE *BEAVER*

The *Beaver* steamship holds the distinction of being the first in the North Pacific. It was built in 1835 and arrived on the West Coast the following year, where it operated for more than half a century, servicing the fur trade and the gold rush, and surveying British Columbia's coastline for the Royal Navy. In its final years, it was bought by locals who converted it into a tugboat for service in the lumber and coal industries.

The ship met its demise on July 26, 1888, when the inebriated crew crashed it on the rocks below Prospect Point. The crew survived, waded out of the water, and headed to the Sunny Side Hotel to finish off their night. For the next four years, the wreck of the *Beaver* was a Stanley Park landmark, and scavenging the old paddle-steamer became a popular pastime for souvenir hunters. (The Vancouver Maritime Museum has a fascinating collection of walking sticks and other items crafted out of salvaged material from the wreck.) The *Beaver* was dislodged and submerged by the waves of a passing ship in 1892 and is now a popular scuba diving site, though scavenging is no longer permitted as the wreck has been designated a heritage site.[50]

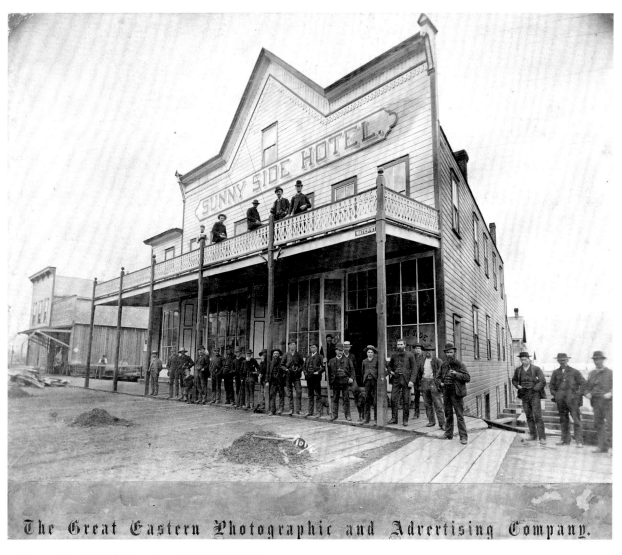

The Great Eastern Photographic and Advertising Company.

18 *Sunny Side Hotel, R.H. Gardiner, 1888, CVA #Bu 371*

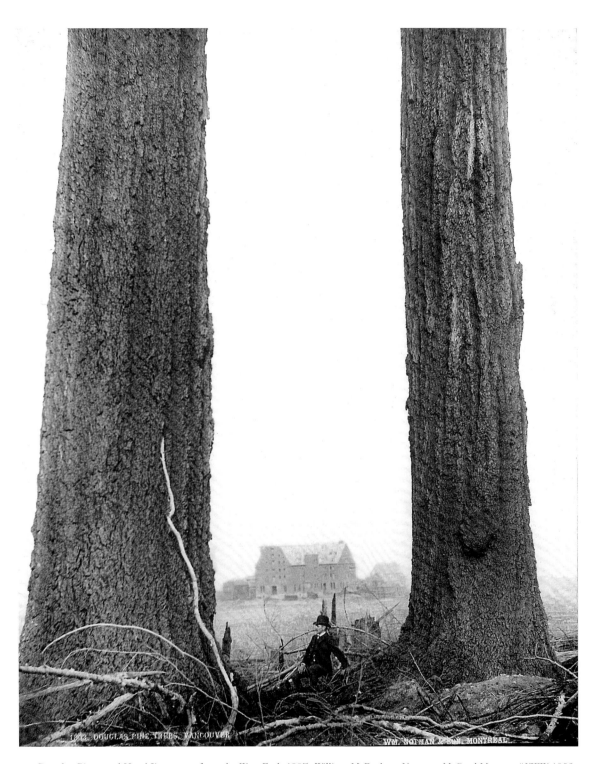

19 *Douglas Pines and Hotel Vancouver from the West End, 1887, William McFarlane Notman, McCord Museum #VIEW 1803*

20 *1900 and 2000 blocks of Nelson Street, 1908, CVA #PAN P103*

EXCLUSIVE NEIGHBOURHOODS

Vancouver's first exclusive neighbourhood was developed in the late 1880s and early 1890s on the bluffs overlooking Coal Harbour, to take advantage of the view. Seaton Street, the name of Hastings west of Burrard before 1915, was known colloquially as "Blue Blood Alley" because its houses seemed palatial by early Vancouver standards.[51] The subsequent residential development of the West End followed similar lines, with enormous houses featuring exquisite landscaping and manicured lawns. Of the people worthy of an entry in the 1908 *Vancouver Elite Directory*, eighty-six percent resided in the West End.[52]

It was not long before less wealthy people seeped into the area, causing the more discriminating of the upper crust to flee to the CPR's Shaughnessy Heights when it opened in 1909. Most of the West End's mansions were eventually subdivided into apartments or rooming houses and were then demolished mid-century to make room for the much more densely populated West End we know today. Only a handful of mansions survive from this era, including Abbott House (720 Jervis Street, considered the last survivor of Blue Blood Alley), Roedde House (1415 Barclay Street), and the Gabriola Mansion (1531 Davie Street). Two other legacies of the West End's posh past are the elite Vancouver and Terminal City Clubs.

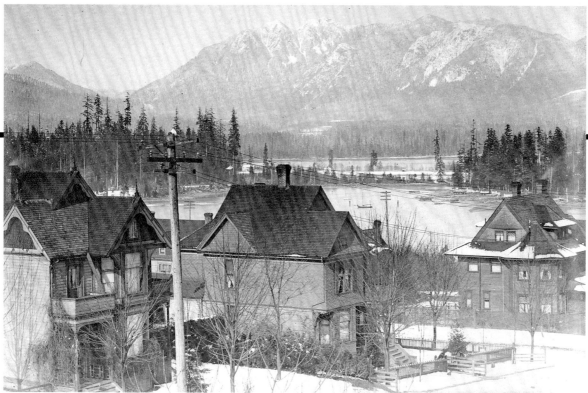

21 *View from 1287 Robson Street, ca. 1903, CVA #Van Sc P123.1*

Vancouver's elite were eager to have their own exclusive enclave again after renters infiltrated the West End. The Canadian Pacific Railway offered lots for sale in their new Shaughnessy Heights neighbourhood for a mere fifty dollars down, but only on the condition that buyers spend at least $6,000 to develop their property. During the Depression, many people lost their homes, and the area was derisively called "Poverty Hill" and "Mortgage Heights." Nevertheless, Shaughnessy remained an upper-class neighbourhood and today, along with West Vancouver, boasts some of the most expensive real estate not only in the Lower Mainland, but Canada.

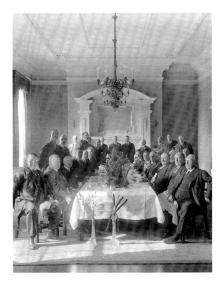

23 Some local "blue bloods" at a Vancouver Club banquet, ca. 1920, CVA #Port P1187

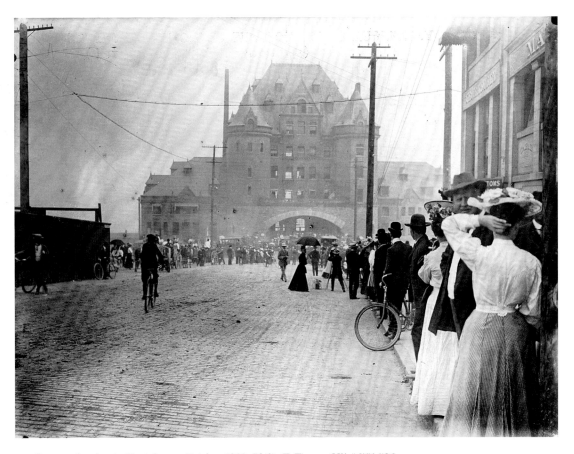

22 Queue to buy lots in Shaughnessy Heights, 1909, Philip T. Timms, CVA #677-526

RUDYARD KIPLING

Rudyard Kipling was one of the most influential cultural figures in the days when the sun was starting to set on the British Empire. Thanks to Disney, he's probably best remembered for *The Jungle Book*, but a century ago the popularity of his numerous poems, novels, and short stories made him one of the most widely read English language writers of the era.

Before becoming famous, Kipling visited Vancouver in 1889 and again in 1892, at which time he called the city "not a very gorgeous place as yet." Still, Kipling felt it was ideally situated and liked that there was no shortage of "proper" Englishmen.

Kipling purchased a lot on what is now the southeast corner of Fraser Street and East 11th Avenue. He wrote about his foray into the Vancouver real estate market in a book about his travels entitled *From Sea to Sea*:

He that sold it to me was a delightful English Boy who, having tried for the Army and failed, had somehow meandered into a real-estate office, where he was doing very well. I couldn't have bought it from an American. He would have overstated the case and proved me the possessor of the original Eden. All the Boy said was: "I give you my word it isn't a cliff or under water, and before long the town ought to move out that way. I'd advise you to take it." And I took it as easily as a man buys a piece of tobacco. *Me voici*, owner of some four hundred well-developed pines, a few thousand tons of granite scattered in blocks at the roots of the pines, and a sprinkling of earth. That's a town-lot in Vancouver. You or your agent hold it till property rises, then sell out and buy more land further out of town and repeat the process. I do not quite see how this sort of thing helps the growth of a town, but the English Boy says that it is the "essence of speculation," so it must be all right. But I wish there were fewer pines and rather less granite on my ground.[53]

Historian Chuck Davis did some digging and found that Kipling paid $500 for the property and sold it in 1928 for $2,000, but lost money after paying $60 a year in taxes. Kipling also got soaked on some property he bought in North Vancouver that turned out to belong to someone else.[54]

24 *Rudyard Kipling, LoC #LC-B2-773*

JACK BLACK

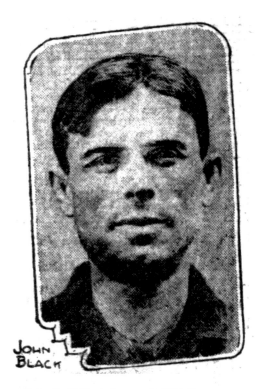

25 *John (Jack) Black, January 5, 1912*, San Francisco Call

Jack Black came to Vancouver in 1894 after he and his Chinese cellmate busted out of a Revelstoke jail using a hacksaw. They hopped a boxcar to Vancouver, where Black rolled a drunk, smoked opium on Dupont Street, and got hog-tied in a botched robbery in Chinatown. He continued his crime spree throughout BC before getting arrested in Victoria and sentenced to two years at the BC Penitentiary in New Westminster, where he was born. While there, the grandfather of another famous New West son, actor Raymond Burr (*Perry Mason, Ironside*), gave him the lash.

Jack Black lived the life of an Old West stock character, colloquially known as a yegg, hobo, grifter, desperado, or hophead. But Black went straight and wrote his memoir, *You Can't Win*, giving us a rare inside view of a world inhabited by the mostly anonymous underclass of the late nineteenth and early twentieth centuries.

The book was a hit when it came out in 1926 and made Jack Black somewhat of a celebrity. The *San Francisco Call* newspaper gave him a job, and later MGM Studios recruited Black as a salaried Hollywood writer to give its crime flicks a touch of authenticity. William S. Burroughs said his classic beat novel *Junkie* was inspired by *You Can't Win*.[55]

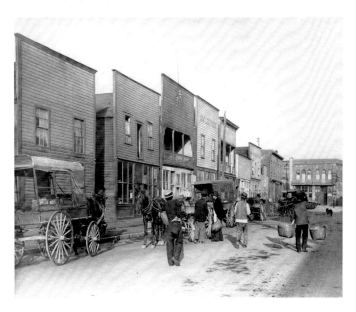

26 *Dupont Street (near East Pender), ca. 1907*, CVA #1376-506

BILL MINER

Bill Miner was the last of the great train robbers. He began his criminal career in the 1860s when he reportedly coined the term "Hands up!" while robbing stagecoaches in the US.[56] By the time he moved to BC in 1903, Miner was a seasoned sixty-year-old train robber. The following year, Miner and his gang allegedly robbed a train near Mission, but the job that landed him in the BC Penitentiary was a botched 1906 train robbery near Kamloops. After serving less than a year of his life sentence, Miner and some accomplices tunnelled their way to freedom.

Miner became a folk hero because, as the newspapers of the day liked to point out, he was a real-life Robin Hood.[57] He made many friends during his short time in BC, and everyone who knew him attested to his generosity and kindness. It was apparently not unusual for Miner to make someone's mortgage payment or, as a trained shoemaker, to cobble shoes for poor children. His good manners earned him the nickname "Gentleman Bandit," and in his many heists, he never killed or maimed anyone.[58] Miner insisted that he had never "bashed a man's head to get the cash."[59]

Miner explained that he did not "consider it a crime to lift money from rich corporations. It is not a crime, it is not a sin, it is neither immoral nor wrong. On the contrary ... I have done what I have done and can look God and man in the face unashamed."[60]

When a Vancouver-to-Seattle train was robbed and one of the trainmen bashed in the head in 1908, Miner wrote an indignant letter to the *Vancouver World* denying rumours that it was his work. Despite his fugitive status, he considered himself on a sort of parole, he said, and had

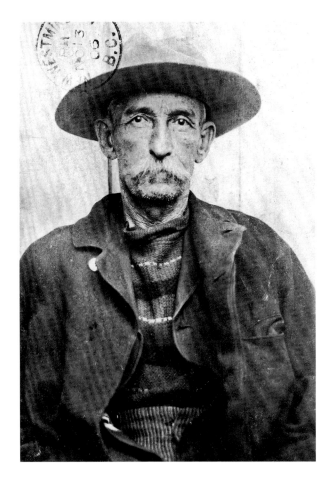

27 *Bill Miner, 1906, CVA #Port P572*

come to realize that "you can get money here [in Seattle] without taking any risks. Business is business, and I want to be left alone." Besides, there was no one there "that I would go into cahoots with in a hold-up anyway."

Miner's career as a legitimate businessman did not last long before he relapsed into his robbing ways. He died in a Georgia prison in 1913, forty-two years after his first conviction.

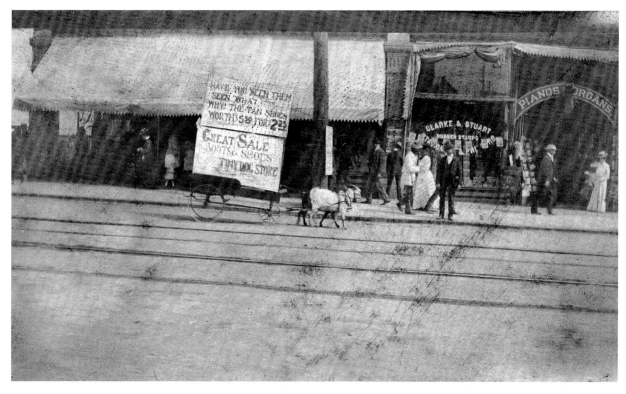

28 *Goats on Hastings Street advertising the Tiny Dog Store, 1904, CVA #371-1316*

THE TINY DOG STORE

The Tiny Dog Store was a clothing and footwear store that opened in 1895 at 70 West Cordova Street. The name came from "the smallest dog that ever saw the light of day, measuring but three inches."[61] The little stuffed dog could be viewed by visiting the store.

Owner Muskett Grossman had a definite flair for publicity. This 1904 photo shows two goats pulling a wagon on Hastings Street advertising a sale. "Have you seen them?" it says. "Seen what? Why! The tan shoes worth 5.50 for 2.25." In another ad, Grossman explains how he kept his prices so low:

> Say, Muskett! You can't give car fare out of your small profits, how do you sell so cheap? You see these other merchants have large corner stores, have two salesmen to pay and over $100 per month rent. I only pay $40, and do my own work. I see, Muskett, you are a worker, a WORKINGMAN'S FRIEND, the man we want [in] these hard times. We will all give you a call at the TINY DOG STORE.[62]

Like many retailers at the time, part of Tiny Dog's business was outfitting prospectors on their way to the Klondike goldfields. "The Best and Cheapest House in Town for Klondike Outfits! Loggers', Miners' and Sailors' Supplies. Everything you want!" promised an ad in the *St James Newsletter*.[63]

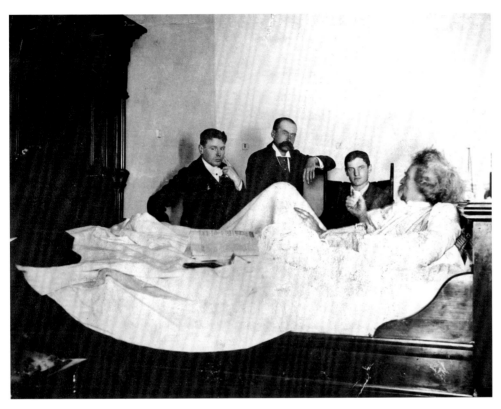

29 *Mark Twain in bed at the Hotel Vancouver, 1895, George T. Wadds, CVA # Port P329*

MARK TWAIN

Mark Twain was as successful as any American writer could hope to be, but by the 1890s he found himself deep in debt from a bad investment. To pay off his creditors, Twain went on a lecture tour of the world that included a stop at the Imperial Opera House on Granville Street.

The stress of being so deeply in debt took its toll on Twain's health, and he spent part of his time here laid up at the Hotel Vancouver. The tour, he said, helped his physical as well as financial recovery: "Lecturing is gymnastics, chest-expander, medicine, mind healer, blues-destroyer, all in one. I am twice as well as I was when I started out—I have gained nine pounds in twenty-eight days and expect to weigh 600 before January. I haven't had a blue day in all twenty-eight. My wife and daughter are accumulating health and strength and flesh nearly as fast as I am. When we reach home a year hence I think we can exhibit as freaks."[64]

From his hotel bed, Twain regaled local newspapermen (pictured) with stories and his opinions on many subjects. In this photo, he's holding a candle and explaining that he rejoiced when electric lights were introduced, but he still travels with a candle because many hotels shut the lights off at night. Twain's manager had to abruptly end his interview because otherwise he would have talked all day.

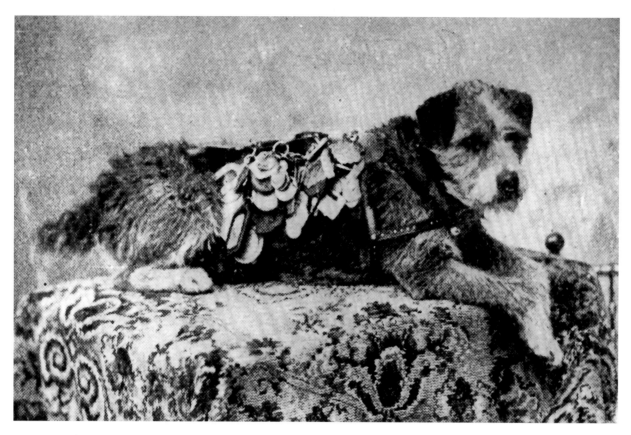

30 *Owney the Dog, 1895, National Postal Museum, Smithsonian Institution #A.2008-42*

OWNEY THE DOG

Owney was a stray dog in Albany, New York, who started hanging around the post office in 1888. He was strangely attracted to the mail bags and eventually began accompanying them on train trips around the country, but he always returned to Albany. He became the unofficial mascot of the US Postal Service and was considered good luck: no train he was on was ever robbed or in an accident. Owney sported a harness to carry the hotel and luggage tags showing where he had travelled. In 1895, the little hobo was sent on a tour of rail lines through Europe and Asia. The same year, he stopped by Vancouver on one of about six trips to Canada.

Owney's Vancouver tags tell the story of his time here. He visited the first Hotel Vancouver and rode the interurban train to New Westminster where he went to the Guichon Hotel and was given the key tag for room number thirty-two. He also made it out to North Bend and checked out the CPR's Fraser Canyon House.

Owney was put down in Toledo, Ohio, allegedly for "ill-temper," in June 1897. The Postal Service had the popular mascot stuffed. Owney and his many tags now live at the Smithsonian's National Postal Museum in Washington, DC.[65]

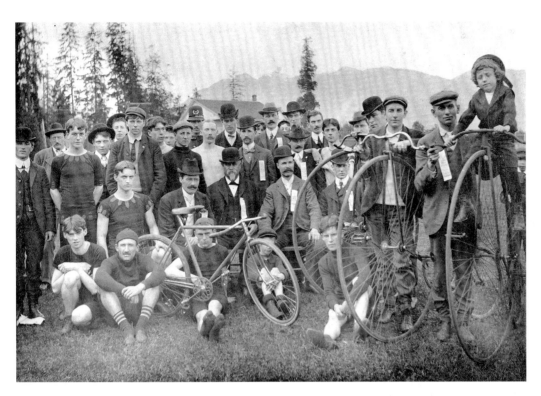

31 *Cyclists at Brockton Point, 1890s, CVA # Sp P15.1*

CYCLING

Cycling was a huge fad in the 1890s. The Vancouver and Terminal City Bicycle Clubs were very active social clubs, and bicycle racing was a staple sporting event at the Brockton Point cycling track in Stanley Park. Even women got in on the action, as one pioneer explained: "I remember well when the first two women rode a bicycle; it was not considered very respectable, just a little bold, but people got used to it, and after a time there were more women riding, until it got to be quite 'the thing,' but at first, it was not considered either graceful or proper."[66]

The high-wheel bikes shown in the photo were used only for novelty races, not transportation, as they had been replaced by regular "safety bicycles" by then. Archivist Major J.S. Matthews noted the challenges of cycling in early Vancouver:

The greatest problem was where to go. The roads— where any existed—were so rough and uneven. Grandview was a clearing; Point Grey Road, North Arm Road (Shaughnessy), Westminster Road (Kingsway) were slits in the forest, Burrard street ended at St Paul's Hospital, and Davie street was a winding trail which led into the West End clearing and lost itself. Cinder bicycle paths—about four feet wide—were beside the wood plank sidewalks on Georgia, Seymour, Third Ave, Westminster Ave, and Powell Street, but for four or five blocks only. The [Stanley] Park Road, paved with white calcinated shells from the Indian midden, was an ideal place to ride.[67]

The bicycle craze faded in the early twentieth century, but old photos show that cycling remained a popular mode of transportation before the proliferation of cars.

FALSE CREEK SHARK

Eight-year-old Harry Menzies was wading in the water near the mouth of False Creek on the evening of July 5, 1905, while a friend was skipping rocks nearby. Fortunately one Mr Dusenberry was in the vicinity and noticed a wave approaching Harry, getting larger and larger. When he saw a dorsal fin, Dusenberry shouted for the boy to get out of the water. He grabbed a pike pole and raced down to the beach to see young Menzies scurry out of the water with an eleven-foot, four-inch (3.5-metre) shark on his heels. According to the *Daily World*, Dusenberry plunged the pike pole into the grounded shark, but this only angered it. The beast showed Dusenberry "the most impressive set of dentistry he had ever seen," at which point he neutralized it by ramming the pike pole eight feet into the shark's mouth.

Meanwhile, the two boys had managed to find a few other men to help do in the "vicious monster," which witnesses said "bled nearly a barrel of gore" before finally expiring. The next day, a crew of twenty men hauled the 1,100-lb (499-kg) carcass out of the water. Recognizing the "Barnum possibilities" of the situation, Dusenberry set up a tent and charged ten cents to view his catch. A sea captain said he was certain it was of the "genuine man-eating Hawaiian variety" that must have followed some vessel all the way from the south seas.[68]

Twenty years later, Jack Bruce, a diver working for the city, encountered a six-foot, two-inch (1.9-metre) long shark while diving at the Second Narrows in Burrard Inlet. The shark circled Bruce, who luckily carried an iron bar for work he was doing on the water mains. After a twenty-minute struggle, Bruce managed to kill the shark with the iron bar. Oddly, just a few days earlier, he had been forced to wriggle free from the clutches of an octopus in the same location.[69]

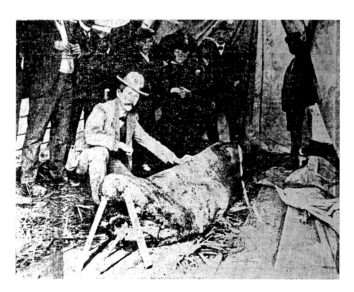

32 *Mr Dusenberry and the False Creek Shark, July 7, 1905,* Vancouver World

INDUSTRIAL WORKERS OF THE WORLD

The Industrial Workers of the World (IWW, a.k.a. the Wobblies) originated in Chicago but had a strong presence in the Pacific Northwest. The first Canadian IWW charter was issued to the Vancouver Industrial Mixed Union No. 322 on May 5, 1906, less than a year after the founding convention.[70] The organization appealed to unemployed resource workers, such as the loggers who flooded early Vancouver between jobs and in the off season. The IWW was also unique in its belief that racial divisions were the bosses' divide-and-conquer strategy. In contrast, much of the early labour movement was dominated by craft unions looking to elevate working conditions and status only for their highly skilled membership, and they often organized against immigrant Asian workers.

The IWW pioneered protest tactics that would later be used by the mainstream labour movement, civil rights activists, and environmentalists, such as getting arrested en masse for violating an objectionable law and overwhelming the criminal justice system. In Vancouver this occurred during the 1909 and 1912 Free Speech Fights in which the City unsuccessfully tried to ban IWW orators from soapboxing on street corners and in open-air meetings at the Powell Street Grounds (today's Oppenheimer Park).

There are a number of unverifiable theories on where the IWW nickname "Wobblies" comes from, but one of the most compelling traces it to a café in Vancouver's Chinatown in 1911. A Chinese-Canadian café owner supported the IWW by giving its members credit and allowing them to hold meetings in his establishment. With his heavy accent, the proprietor's pronunciation of "IWW" sounded more like "Eye Wobble Wobble" to its members, who soon began referring to themselves as Wobblies.[71]

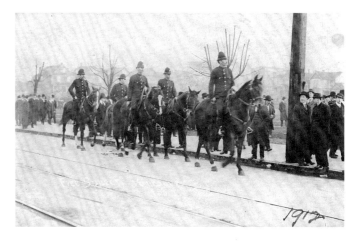

33 *Mounted police at an IWW Free Speech demonstration, 1912, CVA #371-971*

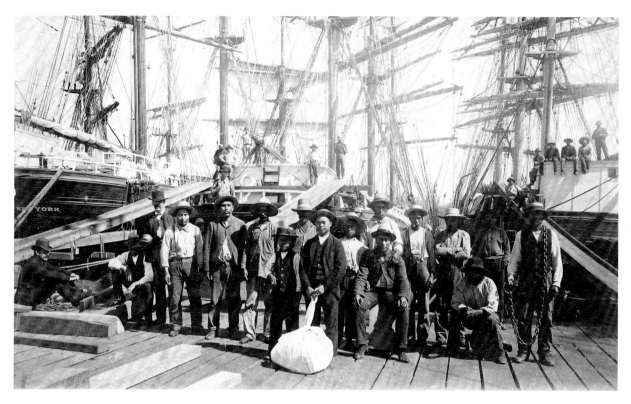

34 *Waterfront workers at Moodyville (in what is now North Vancouver), 1889, Charles S. Bailey, CVA #Mi P2.*

BOWS AND ARROWS

Native men had worked as longshoremen on Burrard Inlet since before Vancouver was incorporated. In many cases, several generations of men from the same family worked on the docks, often beginning when they were as young as thirteen or fourteen years old. Members of several of the families that lived in Stanley Park earned money through longshoring, including William Nahanee, pictured in front holding a bag in this 1889 photo. Many prominent Native leaders worked the docks over the years, including Andrew Paull, Chief Dan George, Chief Simon Baker, and Chief Joe Capilano, who used money earned on the waterfront to finance a trip to London where he lobbied the King to honour treaties with BC's First Nations in 1906.

In the late nineteenth and early twentieth centuries, specialization on the waterfront roughly followed racial lines, and the work gangs comprised primarily of Indigenous men became known for their skill and efficiency in handling lumber. They were also the first to organize a longshoremen's union in 1906, Local 526 of the Industrial Workers of the World, which, although it included non-Native stevedores, was informally known as the "Bows and Arrows." Local 526 lasted less than a year, but other "Bows and Arrows" unions followed until all longshoremen became part of the International Longshore and Warehouse Union after World War II.[72]

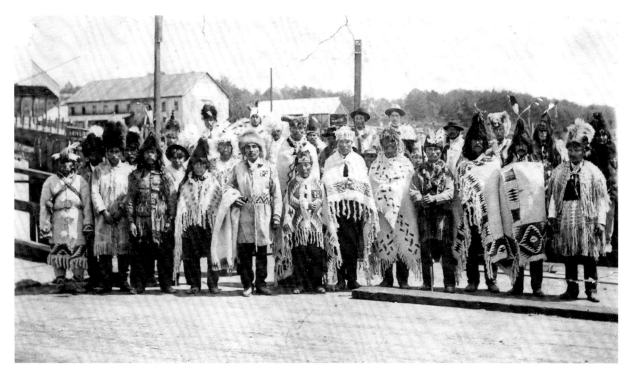

35 *Delegation to see the King, 1906, CVA # In P41.1*

DELEGATION TO SEE THE KING

In 1906 a delegation consisting of Chief Joe Capilano (Squamish), Chief Charley Isipaymilt (Cowichan), and Chief Basil David (Secwepemc) travelled to London to seek an audience with King Edward VII. Their demands included a repeal of the ban on potlatches and removal of restrictive hunting regulations that undermined the self-sufficiency of BC Natives. The delegates also lobbied the King to honour promises made in his name concerning compensation for alienated lands. They pointed out that, unlike the rest of Canada, Aboriginal title had not been extinguished in most of British Columbia.

Planning for the trip took two years and involved numerous intertribal conferences. Chief Capilano travelled the province seeking a mandate to speak on behalf of all BC Natives. He was able to tell the British press that he "carried to the king the handshakes of all 200,000 Indians in British Columbia." [73]

The fifteen-minute meeting with the King failed to bring change, but the visit nevertheless marks a significant milestone in the history of Native-settler relations in BC. Three years after the trip, the first of many province-wide Native political organizations formed to pursue land claims in BC, a struggle that continues over a century later.

36 *Emma Goldman on a streetcar, 1917, LoC # LC-B2-4215*

EMMA GOLDMAN

In 1908, the prominent anarchist Emma Goldman and her manager/lover Ben Reitman went on a lecture tour of the West Coast.[74] By the time they reached Vancouver, they had already been jailed in Bellingham, threatened with violence in Everett, arrested in and run out of Seattle, and detained at the Blaine border crossing, all because of their anarchist beliefs.

An editorial in the *Province* newspaper explained that "Miss Goldman's theories have their origin in the wickedness and perversity of human nature bred in the vice and wretchedness of great cities or under the grinding foot of tyranny." Her anti-authoritarian doctrines may have made sense in the context of Tsarist Russia, but were "absurd … in connection with Canada." Most people only attended her lectures out of curiosity, the *Province* insisted, since there were very few Vancouverites who, "after wrecking their own fortunes by vice or indolence, are desirous of pulling society down to their level."[75]

The *Province* reporter who attended Goldman's talk expected "a series of wild ravings against everyone and everything and threats to murder those in authority." Instead, he was surprised to find the audience "actually cheered, as with perfect enunciation and well-turned sentences Emma delivered a speech which was well thought out and logical."[76]

Goldman was originally booked to speak at the Orange Hall at Gore and Hastings Streets, but the Orangemen cancelled when they found out who she was, and the talk was moved to the Labour Temple at 411 Dunsmuir Street.[77] Otherwise, her visit here was uneventful, despite the hullabaloo in anticipation of her arrival (the *Calgary Herald* predicted bloodshed).[78] Goldman returned to Canada in later years, spending considerable time in Montreal and her final year exiled in Toronto.

WILLIAM HARBECK

William Harbeck was a Seattle-based filmmaker
in the early twentieth century. He was only briefly
in Vancouver but left an important legacy by
shooting the earliest-known film footage of the
city. He bolted a film camera to the front of a
streetcar and filmed Granville, Carrall, Robson,
and Davie Streets to create an urban travelogue, a
popular film genre at the time. (He also did this in
Victoria and several other cities.) Harbeck's final
film assignment was documenting the maiden
voyage of the RMS *Titanic* in 1912.

What makes Harbeck's Vancouver film espe-
cially significant is simply that it survived, given
the extremely delicate nature of early film. It was
discovered in Australia in the 1990s and, after a
long journey and a painstaking restoration, finally
found its way home to Vancouver. A century
after Harbeck rode Vancouver's streetcars, the
Vancouver Historical Society produced an impres-
sive DVD that includes seemingly endless related
historical tidbits and a 2007 film of the same
route to compare with the original footage.[79]

37 *William Harbeck at Takakkaw Falls, Yoho Valley, BC, 1909, BCA
#F-02317*

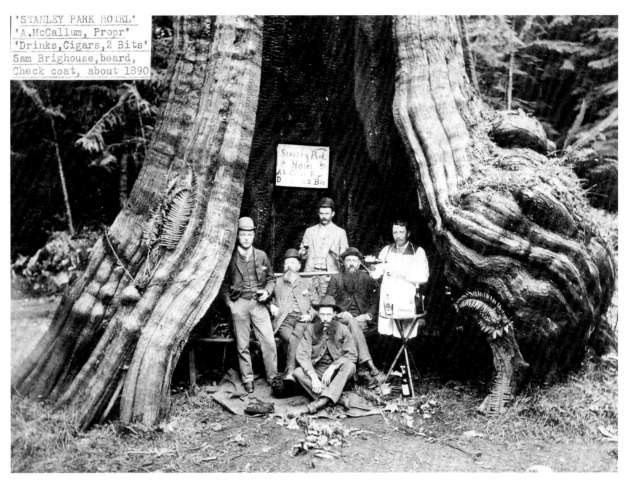

'STANLEY PARK HOTEL'
'A.McCallum, Propr'
'Drinks,Cigars,2 Bits'
Sam Brighouse,beard,
Check coat, about 1890

38 Stanley Park "Hotel" gag photo, ca. 1890, CVA #St Pk P34

STANLEY PARK'S HOLLOW TREE

Stanley Park's 800-year-old Hollow Tree was left alone by nineteenth-century loggers because its rotten centre and knotty wood made it useless for lumber. As the city developed, the giant red cedar became a tourist attraction and has probably been photographed more than any other tree in the country. For years, a professional photographer stationed at a rustic little shack near the tree made a living by snapping portraits of visiting dignitaries, tourists, and Vancouverites, typically with their carriage or motor vehicle backed into the hollow.[80]

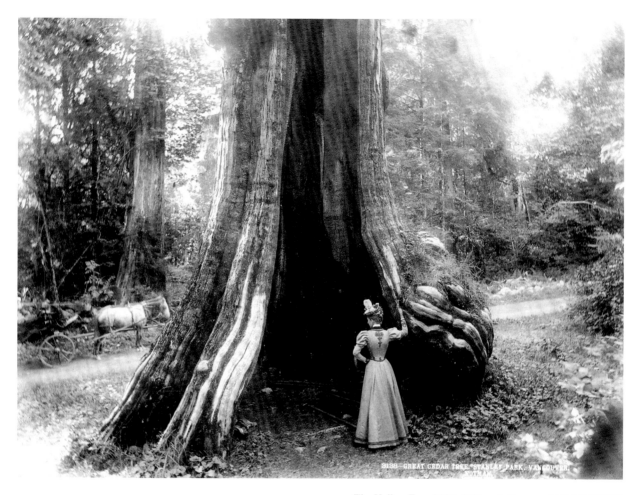

39 *The Hollow Tree, 1897, William J. Notman, LAC # C-037579*

At one time, the tree boasted a sixty-foot girth, but over the years it suffered lightning strikes and other natural indignities that caused it to wither and eventually die. After near-hurricane strength winds ravaged the park in 2006 and destabilized the remains of the tree, the Parks Board had metal braces installed, but eventually voted to cut it down for safety reasons. The decision triggered a public outcry, so the Board agreed to let an activist heritage group save the tree, provided funds be raised from private sources.[81]

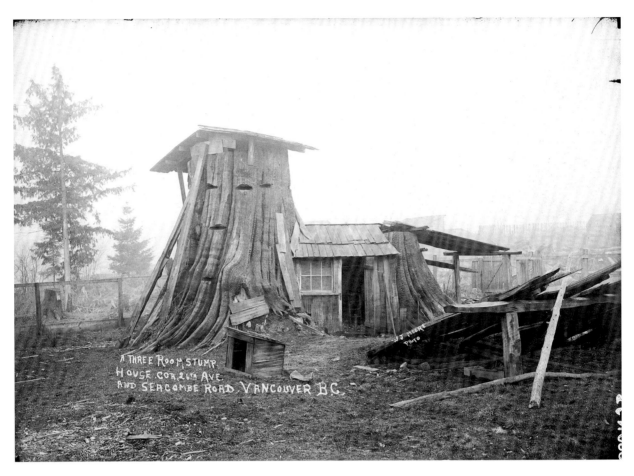

40 *Tree stump house, 1900s, W.J. Moore, CVA, #Sgn 988*

TREE STUMP HOUSE

Taken sometime before 1910, this photo shows a shack built by a Mr Berkman in a giant tree stump on Seacombe Road (now Prince Edward Street) in Mount Pleasant. City archivist Major Matthews provides a description of the little abode from photographer W. J. Moore, who lived nearby: "The location is now 4230 Prince Edward St. It was reached by a short forest trail from Horne Road, now 28th Ave. The lower stump on right was the kitchen, the lower part of the higher stump on left was the living room. The bedroom, doorless, was reached by a ladder removed in daytime to the kitchen."[82]

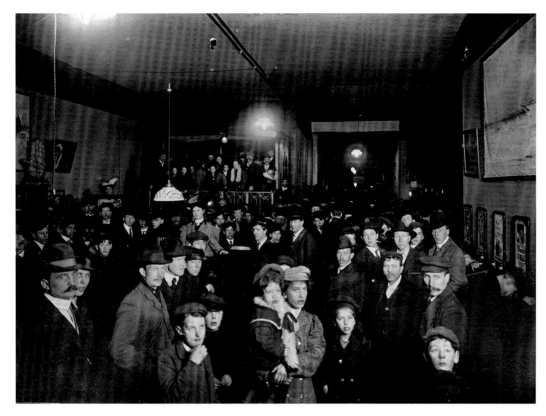

41 *The Exhibit Penny Arcade, 1907, Philip T. Timms, VPL #18688*

EARLY NOVEL THEATRES

Early Vancouver boasted several interesting the-atres. This photo shows the crowd at the Exhibit Penny Arcade for the opening of the "Pullman Flyer," a theatre room designed to simulate the experience of being on a train or showcase travelogue films such as those made by William Harbeck (see p. 51), who filmed Vancouver in the same year this photo was taken.[83]

At the Kinemacolor Theatre on Granville Street at Dunsmuir, the first colour films, with special filters used to create colour images, were shown in Canada in 1913. The Kinemacolor failed to pull in large enough crowds to sustain business and shut down in 1914, only to re-open the next year as the Colonial Theatre.[84]

The Cameraphone Theatre at 64 West Hastings Street was showing films with sound in 1908. The technology wasn't commercially viable and, like the Kinemacolor, the Cameraphone was converted to a regular vaudeville theatre called the National less than a year after it opened.[85]

On August 2, 1897, the first moving picture was shown in Vancouver at Market Hall on the northwest corner of Pender and Main Streets. Coincidentally, this was in the heart of what would become Vancouver's first theatre district, years before the Granville strip became "the-atre row." The show was a demonstration of the Edison Kinetoscope, just four years after it debuted in New York City.[86]

42 *Boris Karloff in* The Bride of Frankenstein, *1935, WikiMedia Commons*

BORIS KARLOFF

A young Englishman and aspiring thespian named William Henry Pratt came to Vancouver in 1909 looking for work. He rented a room at the Hornby Mansions and found work at the Vancouver Exhibition digging the racetrack and fairgrounds for twenty-five cents an hour. The work was hard and the pay low, so young Pratt kept looking. He ran into a family acquaintance who got him a job in a real estate office. Pratt's next job was with the BC Electric Railway Company as a labourer. He did whatever needed doing, including digging ditches, shovelling coal, laying street car tracks, and surveying land. Pratt suffered from a bad back for the rest of his life. In his later years, he recalled being offered a half-interest in a gold mine for $100 during his time in Vancouver. "I had the money, too," he said. "I asked the advice of a banker friend and he said, 'No.' That mine was subsequently sold for three million. But imagine what would have happened to me. It would have ruined me."[87]

In his spare time, Pratt looked for work at theatre companies touring through town, but without luck. Claiming to be an experienced stage actor, he contacted an agent in Seattle. Using the name Boris Karloff, he made his stage debut on his twenty-fourth birthday at the Nelson Opera House in a play called *The Devil*. Eventually Karloff moved to the US, and his iconic 1931 performance in *Frankenstein* launched one of the most successful horror movie careers in history.

In 2005, historian Greg Nesteroff discovered the original Bride of Frankenstein, a Vancouver woman named Grace Harding, who wed Pratt at the appropriately gothic Holy Rosary Cathedral on February 23, 1910. Harding was the first of Karloff's six wives. She divorced him in 1913 on the grounds of adultery, then she remarried ten days after the divorce papers were finalized.[88]

EMILY CARR

Victoria-born and raised painter Emily Carr was
British Columbia's first art star. She spent only a
few years in Vancouver, but—with a university
named after her and a large collection of her work
the jewel of the Vancouver Art Gallery's perma-
nent collection—Emily Carr left a significant mark
on the city.

Carr described Vancouver as a "little town"
that was "growing hard" when she came here
in 1906: "Almost every day you saw more of her
forest being pushed back, half-cleared, waiting
to be drained and built upon—mile upon mile
of charred stumps and boggy skunk-cabbage
swamp, root-holes filled with brown stagnant
water, reflecting blue sky by day, rasping with frog
croaks by night, fireweed, rank of growth, spring-
ing from the dour soil to burst into loose-hung,
lush pink blossoms, dangling from red stalks,
their clusters of loveliness trying to hide the hid-
eous transition from wild to tamed land."[89]

Carr's first paid work in Vancouver involved
teaching painting to rich women at the Vancouver
Ladies' Art Club, but she was fired after only a
month. In her autobiography, she described the
club as "a society of women who intermittently
packed themselves and their admirers into a small
rented studio to drink tea and jabber art jargon."
The club women had treated her poorly and she,
in turn, put them off by smoking cigarettes, cuss-
ing, and harshly criticizing their work.[90] She then
opened a studio at 570 Granville Street where
she taught art to children until 1910. "Young
Vancouver had before been taught only from
flat copy," she wrote. "I took my classes into
the woods and along Vancouver's waterfront to
sketch."[91]

43 *Emily Carr, ca. 1889, BCA #I-60891*

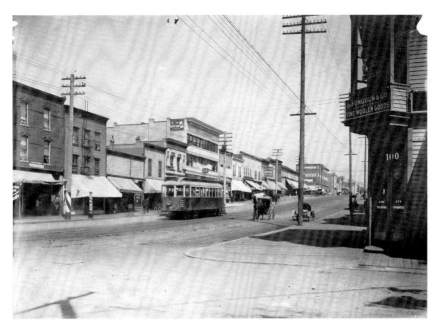

44 *Hastings at Columbia Street, 1906, Philip T. Timms, CVA #677-649*

RAILWAY PORTERS' CLUB

Former lacrosse star Lige Scurry opened the first exclusively black space for young Vancouver's sparse black population, a social club at 107 East Hastings Street (the second building from the left) in 1904. He called it the Railway Porters' Club because that was one of the few occupations open to black men in Vancouver; porters could rent rooms there if they were from out of town or new to the city. Black women, including sex-trade workers, also frequented the club. According to the *Province* newspaper, "its dozen or more handsomely-fitted rooms include billiard and card parlors, and a bar sumptuously furnished."[92]

It was not long before police raided the club, claiming it was a front for prostitution. Whether it was or not, police failed to produce any evidence, and those arrested in the raid were released except for Lige Scurry. At his trial, Scurry's lawyer argued that it was nothing more than a social club: "The women went to Scurry's premises merely for the innocent purpose of getting their meals in a house that was open to colored people and to colored people only ... All classes of people in Vancouver had their various resorts. For the well-to-do there were the better class clubs. For those who liked that sort of thing there were various tea rooms, and for those who were inclined that way there were the YMCA and the YWCA."[93]

The charge of operating a bawdy house was dropped due to lack of evidence, but Scurry was nevertheless sentenced to three months' hard labour and a fifty-dollar fine for operating without a liquor licence, and the club shut down. City directories show that the Railway Porters' Club resurfaced at 149 East Pender Street in 1908, but it is not known if Scurry was involved. Decades later, the site of the first club housed the social hub for another local subculture when local punks took over the Smilin' Buddha Cabaret.

45 *Canton Alley, 1928, LAC #A126739*

ALLEYS

Early Vancouver had a number of alleys that were also commercial and community hubs. The oldest is Trounce Alley, north of Cordova Street between Carrall and Abbott Streets. It was given the name by early Vancouver businessman F.W. Hart after a similar alley with that name in Victoria.[94] Chinatown's Shanghai Alley was the location of a 500-seat theatre where Sun Yat-sen, China's first president, spoke during his 1910 visit. Like its neighbour, Canton Alley, Shanghai Alley had buildings with storefronts on the ground floors and residences and meeting halls on the upper levels. Canton Alley was an enclosed courtyard with only one entrance on Pender Street. After a white mob attacked Chinatown in a 1907 race riot, a lockable iron gate was added as a security measure.[95]

Market Alley took its name from the Market Hall on Westminster Avenue (now Main Street) at Pender Street that housed a community hall,

public market, and city hall. Market Alley was the laneway north of Pender between Main and Carrall Streets, which had commercial operations facing onto the alley up until the mid-1970s when American draft dodger Jack Todd described his first encounter with the alley: "The Red Door, Yellow Door, Green Door, narrow, steamy joints accessible only through the alley, known only by the color of their doors and the fact that the food is plentiful and cheap—all you can eat for a dollar."[96]

Hogan's Alley ran between Union and Prior from Fountain Chapel on Jackson to just east

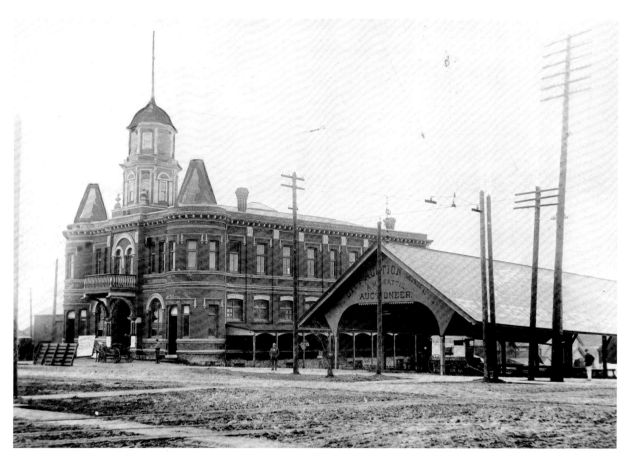

46 *Market Hall, 1895, CVA #City P6*

of Main. Its origins are obscure, but old-timers remembered it as a lively strip, especially before World War II. It was rife with gambling dens, juke joints, and bootleggers, and was a popular party destination for people from other neighbourhoods "slumming it" in the East End. With its proximity to the train station and Fountain Chapel, a lot of Hogan's Alley residents were part of the area's black community.[97] Hogan's Alley was frequently at the centre of anti-vice and urban renewal campaigns before the war, and was razed in the late 1960s and early '70s to build the Georgia Viaduct.[98]

47 *Hogan's Alley, 1958, A.L. Yates, CVA #Bu P508.53*

VANCOUVER LACROSSE CLUB GOES
TO NEW WESTMINSTER

48 *Lacrosse cartoon by Fitzmaurice, September 26, 1908,* The Province

LACROSSE

Field lacrosse was one of the most popular sports in early Vancouver. Intense competition between New Westminster, Vancouver, and Victoria added to the excitement, fuelling occasional violence on the field and in the stands. Hockey legend and lacrosse player Fred "Cyclone" Taylor recalled that "if you sat in a New Westminster section and cheered for Vancouver, you were taking your life into your own hands. The ladies were extremely emotional and used to fight all the time."[99]

The cartoon reflects the rivalry between New Westminster and Vancouver, but even *Province* cartoonist Fitzmaurice could not have predicted the level of violence that broke out in New Westminster the next day. A series of bloody skirmishes between players escalated until New West fans rushed onto the field and tried to swarm Vancouver player Vernon Green. The team's manager and George Paris, its trainer, helped Green escape to the dressing room. The 200-strong mob tried to follow Green, but found Paris barring their way. As the heavyweight boxing champion

of Western Canada, George Paris knew how to defend himself, but self-defence in this case would require more than fists; he pulled out a pistol but was quickly disarmed by men in the mob. During the scuffle, the gun discharged and a bullet pierced one of their coats. Paris, a black man, was only rescued from the crowd (which was now chanting "Lynch him! Lynch him!") when the police took him away in handcuffs.[100]

George Paris's heroism cost him a sixty-dollar fine and his gig as a lacrosse trainer. His sports career did not end there, however. The following spring, he was the in-house boxing instructor at the Vancouver Athletic Club when Jack Johnson fought his first match as the heavyweight boxing champion of the world. Paris befriended Johnson and joined him on a European tour as his personal trainer. After returning to Vancouver, Paris spent a few years as a professional musician before being hired as the boxing trainer for the Vancouver Police Department.

49 *George Paris, September 2, 1947*, The Province

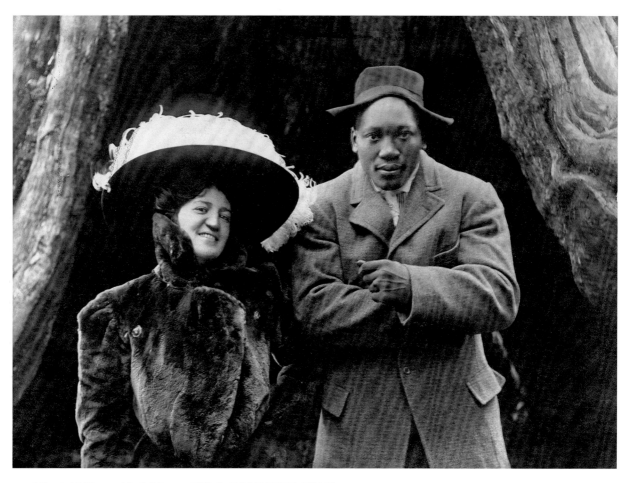

50 J *Hattie McClay and Jack Johnson, 1909, LoC # LC-USZ62-130102*

JACK JOHNSON

Jack Johnson became the first black heavyweight boxing champion of the world after clobbering Canadian Tommy Burns in Australia on Boxing Day in 1908. His next fight was at the Vancouver Athletic Club on March 10, 1909.

Johnson travelled to Vancouver with a white woman named Hattie McClay. Despite being the most famous black man on the planet, Johnson and his paramour were turned away from several hotels that wouldn't rent to a mixed-race couple.

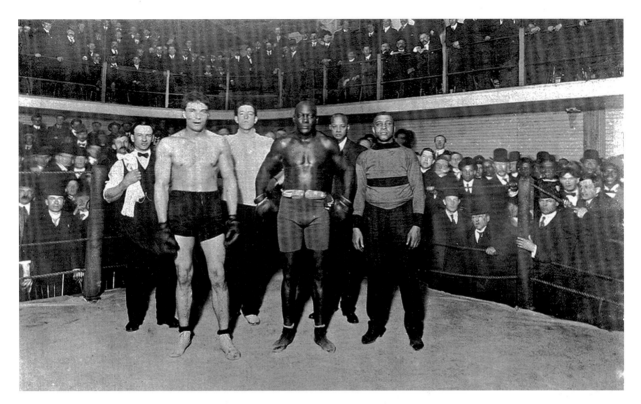

51 *Front row: Victor McLaglen, Jack Johnson, and George Paris at the Vancouver Athletic Club, 1909 (from Thirkell, Fred and Bob Scullion,* Vancouver and Beyond: During the Golden Age of Postcards, 1900-1914 *[Victoria: Heritage House, 2000]).*

They had to stay at George Paris's (p. 62) home in the East End until they finally got a room at the Dominion Hotel on Abbott Street.[101]

Johnson was scheduled to fight Denver Ed Martin, a.k.a. the "Colorado Giant," in a demonstration bout, but Martin skipped town. A little-known boxer from Tacoma named Victor McLaglen agreed to a match with the champ. Johnson easily beat McLaglen, who would find greater success in Hollywood than he did in the ring, winning the 1935 best actor Oscar for his role in *The Informer*.

While in Vancouver, Johnson played cards at the Railway Porters' Club (p. 58), saw a vaudeville show at the Pantages, and drove around Stanley Park where he and Hattie posed as Napoleon and Josephine for a photograph with the Hollow Tree. Johnson said later that he felt an affinity with Napoleon, who had also fought his way up from humble origins and against incredible odds.[102]

TOMMY BURNS

Born near Hanover, Ontario, Tommy Burns was the first Canadian heavyweight boxing champion of the world and, at five feet, seven inches (171 cm), also the shortest. He was the first champ willing to fight challengers of any race, which led him to lose his title to Jack Johnson in 1908.

Afterward, Burns returned to playing lacrosse, which, he said, was "seemingly made for the development of a fighter. It is probably one of the hardest games to master in the entire category of sport, requiring unlimited endurance, wonderful accuracy of eye and strength in every limb ... it gives you the same mighty strength [as weight lifting], but makes you a spindle of steel springs. The crack player is like a cat on his feet."[103]

Burns was back in the news in 1910 when Vancouver sports promoter Con Jones offered him $1,000 to play in a single lacrosse game against the reigning New Westminster Salmonbellies. He found himself targeted by Salmonbellies player George Rennie, who slashed Burns on the shins with his stick. When the ex-pugilist refused to retaliate, Rennie began throwing punches. Burns dodged and deflected Rennie with his elbows and still refused to engage. Vancouver won that game seven-to-one in front of 8,000 howling fans, and Burns received kudos for his gentlemanly behaviour on the field.

Sports promoter Con Jones would probably have included Tommy Burns on the dream team

52 *Tommy Burns (third from the left), 1910, W.J. Cairns, CVA #371-584*

he was spending a small fortune putting together for the Vancouver Lacrosse Club, but Burns injured his knee in a lacrosse match in Vancouver and then was badly hurt in a collision with an interurban train in Seattle.[104]

Tommy Burns turned to religion and moved to California, but he was visiting Vancouver when a heart attack killed him in 1955. By then his past accomplishments had been pretty much forgotten, and only a handful of people attended his funeral, which was paid for by an anonymous donor. After hockey legend and former lacrosse player Fred "Cyclone" Taylor learned that Burns was buried in an unmarked grave in Vancouver, he and three other old-timers, who had played lacrosse against Burns in Ontario, raised money for a proper gravestone commemorating the former champ.[105]

12 For a more comprehensive listing of the various historical settlements, see Bruce Macdonald, *Vancouver: A Visual History* (Vancouver: Talonbooks, 1992).

13 Major James Skitt Matthews, *Conversations with Khahtsahlano, 1932–1954* (Vancouver: City of Vancouver, 1955), 46.

14 Major James Skitt Matthews, *Early Vancouver, vol. 2* (Vancouver: City of Vancouver, 2011), 341.

15 Major James Skitt Matthews, *Early Vancouver, vol. 3* (Vancouver: City of Vancouver, 2011), 234.

16 McDonald, *Making Vancouver*, 48–51.

17 David W. Black, "Shell Middens," The Canadian Encyclopedia [online], accessed July 17, 2013, http://www.thecanadianencyclopedia.com/articles/shell-middens.

18 Susan Roy, "'Who Were These Mysterious People?': The Marpole Midden, and the Dispossession of Aboriginal Lands in British Columbia," *BC Studies* no. 152 (Winter 2006/7), 67–95.

19 *Vancouver Sun*, October 1, 2012.

20 Eve Lazarus, *At Home with History: The Untold Secrets of Greater Vancouver's Heritage Homes* (Vancouver: Anvil Press, 2007), 36.

21 E. Pauline Johnson (Tekahionwake), *Legends of Vancouver* (Toronto: McClelland & Stewart, 1922), 113–124.

22 *Daily Mail and Empire*, April 24, 1899.

23 *Daily Mail and Empire*, April 25, 1899.

24 *Montreal Gazette*, August 16, 1913.

25 George Vancouver, *A Voyage of Discovery to the North Pacific Ocean, and Round the World* (London: G.G. and J. Robinson, 1798), 300.

26 Ibid., 301.

27 Ibid., 302.

28 Ibid., 312.

29 Ibid.

30 R.H. Alexander, "Reminiscences of the Early Days of British Columbia," in *The Canadian Club of Vancouver: Addresses and Proceedings, 1910–1911* (Vancouver: Saturday Sunset Press, [1910–11]), 16.

31 Ibid., 13. Chinook Jargon is a simple, hybrid language that was developed to facilitate communication amongst the diverse groups involved in the fur trade.

32 McDonald, *Making Vancouver*, 52.

33 Ibid., 28–29.

34 *Victoria Daily Times*, June 17, 1886.

35 Raymond Hull and Olga Ruskin, *Gastown's Gassy Jack: The Life and Times of John Deighton of England, California and Early British Columbia* (Vancouver: Gordon Soules Economic Research, 1971), 24–29.

36 Ibid., 34.

37 *British Colonist*, July 30, 1872.

38 *Mainland Guardian*, June 15, 1872.

39 *Mainland Guardian*, August 7, 1872. The Battle of Gravelotte took place in August 1870 in the Franco-Prussian War.

40 *British Colonist*, August 2, 1872.

41 *British Colonist*, April 28, 1888.

42 Major James Skitt Matthews, *Early Vancouver, vol. 5* (Vancouver: City of Vancouver, 2011), 11–12.

43 *British Colonist*, August 7, 1887.

44 *British Colonist*, September 29, 1891.

45 *British Colonist*, November 15, 1891.

46 Megan Schlase, "Camping at the Seaside," *AuthentiCity* [website], City of Vancouver Archives. Accessed April 2, 2013, http://www.vancouverarchives.ca/2011/06/camping-at-the-seaside; Major James Skitt Matthews, *Early Vancouver, vol. 7* (Vancouver: City of Vancouver, 1911), 141.

47 *New York Times*, June 16, 1886; *Toronto World*, June 16, 1886.

48 *Victoria Daily Times*, June 17, 1886.

49 *Victoria Daily Times*, June 14, 1886.

50 James P. Delgado, *Waterfront: The Illustrated Maritime Story of Greater Vancouver* (Vancouver: Vancouver Maritime Museum/Stanton Atkins & Dosil, 2005), 26–27.

51 Michael Kluckner, *Vancouver: The Way It Was* (Vancouver: Whitecap Books, 1984), 102. Some sources say "Blue Blood Alley" referred to West Georgia Street, which may indicate that the general area bore that nickname.

52 Lazarus, *At Home with History*, 69–70.

53 Rudyard Kipling, *From Sea to Sea: Letters of Travel, Volume 2* (New York: Doubleday & McClure, 1899), 51–54.

54 Chuck Davis, *History of Metropolitan Vancouver* [website], accessed March 14, 2013, http://www.vancouverhistory.ca/archives_kipling.htm.

55 *Vancouver Sun*, August 7, 2008; Jack Black, *You Can't Win*, 2nd ed. (Oakland, CA: AK Press, 2001).

56 *Washington Times*, September 27, 1908.

57 See, for example, *Victoria Daily Colonist*, August 16, 1907.

58 Peter Grauer, *Interred with Their Bones: Bill Miner in Canada, 1903–1907* (Kelowna, BC: Sandhill Books, 2006), 417, 455–458.

59 Ibid.

60 Bill Miner, *Vancouver World*, May 12, 1908.

61 *Vancouver, the Queen City of the Wonderful West: Souvenir Edition of the Daily Province* (Vancouver: *Daily Province*, 1898), 59.

62 *Lodge History of the Independent Order of Odd Fellows, Knights of Pythias and A.O.U.W.* (Vancouver: Order Publishing Company, 1895), 40.

63 Jane Turner, "Reflecting Community and Culture," *Pax: Advent, vol. 1, no. 1* (2008), [online], accessed July 11, 2013, http://www.stjames.bc.ca/assets/client/File/Pax/Pax1-Web.pdf.

64 Mark Twain, *Mark Twain: The Complete Interviews*, ed. Gary Scharnhorst (Tuscaloosa: University of Alabama Press, 2006), 192.

65 National Postal Museum, *Smithsonian Institute* [website], accessed 21 February 2013, http://www.postalmuseum.si.edu/exhibits/2c1f_owney.html.

66 Mrs Frank Harris, June 16, 1937, quoted in Major James Skitt Matthews, *Early Vancouver, vol. 4* (Vancouver: City of Vancouver, 2011), 204.

67 Major James Skitt Matthews, note accompanying City of Vancouver Archives photo #Sp 18.

68 *Vancouver World*, July 7, 1905.

69 *Vancouver Sun*, January 8, 1925.

70 Paul A. Phillips, *No Power Greater: A Century of Labour in British Columbia* (Vancouver: BC Federation of Labour/Boag Foundation, 1967), 48–49.

71 Mark Leier, *Where the Fraser River Flows: The Industrial Workers of the World in British Columbia* (Vancouver: New Star Books, 1990), 35.

72 For more on native longshoremen and the Bows and Arrows, see Andrew Parnaby, *Citizen Docker: Making a New Deal on the Vancouver Waterfront, 1919–1939* (Toronto: University of Toronto Press, 2008).

73 Keith Thor Carlson, "Rethinking Dialogue and History: The King's Promise and the 1906 Aboriginal Delegation to London," *Native Studies Review* 16, no. 2 (2005): 1–38.

74 Ben Reitman was notorious in his own right for his work with the downtrodden in Chicago, where he treated prostitutes and founded a "hobo college." His pioneering sociology of hobos informed the work of Vancouver's own hobo expert during the depression, Reverend Andrew Roddan of the First United Church. See: Andrew Roddan, *Vancouver's Hoboes* (Vancouver: Subway Books, 2004).

75 *Province*, December 17, 1908.

76 Ibid.

77 *Province*, December 15, 1908.

78 *Morning Leader*, December 17, 1908.

79 Vancouver Historical Society [DVD], *City Reflections: 1907-Vancouver-2007*, Vancouver, 2008.

80 Fred Thirkell and Bob Scullion, *Vancouver and Beyond: During the Golden Age of Postcards, 1900–1914* (Victoria: Heritage House, 2000), 81–84.

81 Richard M. Steele, *The Stanley Park Explorer* (North Vancouver: Whitecap Books, 1985), 158; Daniel J. Pierce, producer, *The Hollow Tree* (film documentary, Ramshackle Pictures, 2011).

82 Major J.S. Matthews, caption included with W.J. Moore photograph, City of Vancouver Archives # Sgn 988.

83 Vancouver Historical Society [DVD], *City Reflections: 1907-Vancouver-2007*, Vancouver, 2008.

84 Andy Coupland and John Atkin, "Colonial Theatre: Granville Street," *Changing Vancouver* [website], accessed February 7, 2013, http://changingvancouver.wordpress.com/2012/03/20/colonial-theatre-granville-street/.

85 Jason Vanderhill, "Lost Backdrops of Vancouver," *Illustrated Vancouver* [website], accessed March 14, 2013, http://illustratedvancouver.ca/post/22976241259/lost-backdrops-of-vancouver.

86 Vancouver Heritage Foundation, "List of Nominated Sites (February 2011)," *Places that Matter*, accessed March 4, 2013, http://www.vancouverheritagefoundation.org/wp-content/uploads/2013/01/Nominated-sites-February-2011.pdf.

87 Boris Karloff, quoted in David Spaner, *Dreaming in the Rain: How Vancouver Became Hollywood North by Northwest* (Vancouver: Arsenal Pulp Press, 2003), 22.

88 Greg Nesteroff, "Boris Karloff in British Columbia," *British Columbia History* 39, no. 1 (2006): 16–21.

89 Emily Carr, *Growing Pains: The Autobiography of Emily Carr* (Vancouver: Douglas & McIntyre, 2005), 253.

90 Ibid., 251.

91 William Wylie Thom, "The Fine Arts in Vancouver, 1886–1930: A Historical Survey" (MA thesis, University of British Columbia, 1969), 59.

92 *Province*, September 30, 1904.

93 *Vancouver World*, January 21, 1905.

94 Matthews, *Early Vancouver, Volume. 3*, 224.

95 "Shanghai Alley and Canton Alley, 1885–1954," *Passage of Changes* [website], accessed March 28, 2013, http://www.generasian.ca/CHA-eng1/66.165.42.33/cv/html/en/panel_02.html.

96 Jack Todd, *The Taste of Metal: A Deserter's Story* (Toronto: HarperCollins, 2001), 143.

97 The best source for information and anecdotes on Hogan's Alley are the oral histories in Daphne Marlatt and Carol Itter, eds., *Opening Doors: In Vancouver's East End: Strathcona*, reprint edition (Madeira Park, BC: Harbour Publishing, 2010).

98 For example, see *Vancouver Sun*, April 11, 1939.

99 Fred Cyclone Taylor, quoted in David S. Savelieff, *A History of the Sport of Lacrosse in British Columbia* (s.l.: s.n., 1972).

100 *Daily World*, September 27, 1908; Province, September 30, 1908.

101 *New York Times*, March 11, 1909.

102 For the full story, see Tom Hawthorn, "When Jack Johnson fought in Vancouver," *The Tyee*, August 18–19, 2004, http://thetyee.ca/Sports/2004/08/18/JackJohnson/.

103 *Reading Eagle*, December 30, 1906.

104 *New York Times*, December 15, 1910.

105 *Ottawa Citizen*, September 2, 1961.

CHAPTER TWO

Terminal City: 1911–1939

WITH MORE THAN 100,000 RESIDENTS by 1911, the city of Vancouver was now a city in fact, not just in name. It had finished off another development and growth spurt and was heading toward another recession late in 1912. As anticipated, completion of the Panama Canal in 1914 was a great boon for Vancouver's seaport, but the city had to wait until the end of World War I before it could fully reap the economic benefits of the canal. The city also built its first university, though its construction was also interrupted by the war, leaving students of the fledgling University of British Columbia to attend classes in rickety shacks in Fairview, a neighbourhood on Vancouver's west side.

Vancouver took a few years to crawl out of a post-war recession that was marked by out-of-control inflation and widespread industrial discontent among veterans who felt they deserved better treatment after sacrificing so much overseas for the good of the British Empire. Vancouver was home to Canada's first general strike in 1918 and another strike in solidarity with the Winnipeg General Strike

53 *Granville and Hastings streets, 1921, W.J. Moore, CVA #Str P43.1*

in 1919, and experienced a wave of unionization that saw the Vancouver Police Department among the country's first unionized law-enforcement agencies. By the mid-1920s, industrial relations had settled down, and the province was waging a drawn-out legal battle with Ottawa against discriminatory freight rates on goods shipped by train through the Rocky Mountains. The issue was settled in BC's favour, ensuring that Vancouver's harbour would be a major—and lucrative—North American seaport. The city's current boundaries were set at the end of the 1920s when Vancouver amalgamated with South Vancouver and Point Grey.

In the 1920s and '30s, Granville and Hastings Streets shared duties as the main retail and entertainment strips, with the former considered somewhat more upscale. Spencer's, Hudson's Bay Company, and Woodward's grew to become the city's undisputed department store triumvirate, and theatres, cafés, and clubs abounded on both streets. The first neon sign went up on the Vancouver Block clock tower in 1925, beginning a trend that would see the city become the neon capital of North America. The vaudeville scene established at the turn of the century continued to flourish well into the 1920s and beyond, largely because the Pantages and Orpheum theatres were firmly established on West Coast circuits, which brought top-notch entertainment to town and added to the flow of people and cultural influences coming into the city.

Marred by the Chinese Exclusion Act, the expulsion of Native communities from Stanley Park, the infamous Janet Smith murder case, and the formation of the short-lived Knights of the Ku Klux Klan of Canada, the decade of the 1920s was possibly the most racist period in Vancouver's history. Local and visiting American blacks, however, managed to create a small but vibrant jazz scene, were well represented on vaudeville stages, and were largely responsible for turning Hogan's Alley, near Main Street, into an inclusive cultural hotspot despite the racism of the era.

Because of British Columbia's resource-based economy, the Great Depression hit Vancouver especially hard. All three levels of government spent much of the decade fighting over who was responsible for the throngs of unemployed men who flocked to Vancouver looking for work, while Communists took the lead in organizing demonstrations and what became the On to Ottawa Trek around the theme of "Work and Wages." But not everything about the Depression was depressing. Guy Glover of the Progressive Arts Club theatre company remembered the 1930s as an exciting and creatively fertile decade: "It was a decade of discovery for a whole lot of people and not just in the theatre—political discovery, social discovery. Think of the things in Canada that trace their roots back to the thirties—a political party, all kinds of notions of social progress, social legislation. The thirties were a time of breaking new ground, as it were, for all sorts of things. They may have been lost years for some people who are inattentive to the recent past. All over the world it was a lively decade and, fortunately, Canada shared in that."[106]

Few things brought people together, and sometimes into conflict, more than sports. Lacrosse had been the city's dominant sport until an indoor ice rink, the Denman Arena, built in 1911, made hockey a practical pastime in balmy Vancouver. Baseball, boxing, cricket, and an array of other sports were also very popular and drew thousands out to the major sports fields: Brockton Point in Stanley Park, the

Cambie Street Grounds downtown, and the Powell Street Grounds in the East End. Sports provided another outlet for social tensions, as rivalries sometimes intensified the competition on the field and in the arenas. On the other hand, the playing fields of sports were generally far more level than those in the political and economic arenas, and teams like the Japanese Asahi baseball team and the North Shore Indians lacrosse club flourished and even dominated their respective sports.

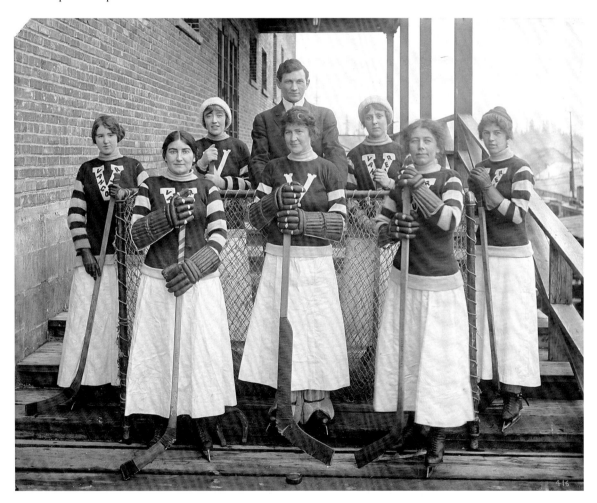

54 *Vancouver Women's Hockey Team, 1920, Stuart Thomson, CVA #99-58*

DR SUN YAT-SEN

Dr Sun Yat-sen is considered the father of modern China in both Taiwan and mainland China because he led the revolution that overthrew the Qing Dynasty and established a republican state in 1912. Part of his strategy was to visit Chinese diaspora communities around the world to raise funds and support, and to this end he came to Vancouver in 1910 and 1911. According to local lore, Sun stayed at the Chinese Freemasons building and what's now the Pennsylvania Hotel, both on Carrall Street. By the time he arrived, Sun Yat-sen already had nine attempted uprisings under his belt.[107]

Sun Yat-sen found opponents as well as supporters in Vancouver. There were skirmishes between the factions and wars of words in the Chinese press over the issue. Opponents felt reform, not revolution, was the answer to China's problems and referred to him as "Bullshit Sun."[108]

Years later, East End resident Chang Yun Ho recalled one of Sun Yat-sen's talks in Chinatown: "His talk lasted for two or three hours, and then he asked for suggestions and people asked him questions about his plans. He would answer in a very calm, confident tone. Some people contributed money on the spot. I did too, and Dr Sun wrote out a receipt to each person who contributed. After the overthrow, if you went back to China with the receipt, he would refund your money … one man who donated $100 was later given a life pension."[109]

In 1986, the Dr Sun Yat-sen Classical Garden opened in Vancouver; the first full-size Chinese garden of its kind outside of China, it remains one of Chinatown's most popular attractions.

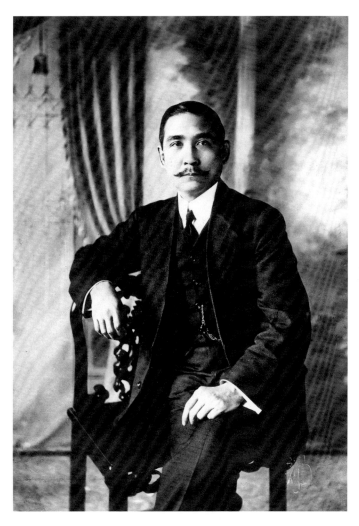

55 *Dr Sun Yat Sen in Vancouver, 1911, Yucho Chow, Chinese Community Library Services Association*

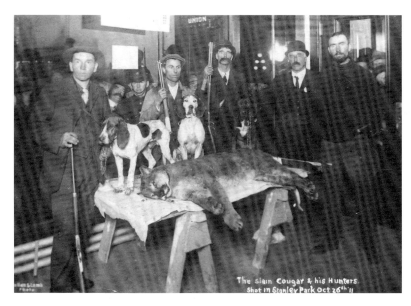

56 *Hunters and the Stanley Park cougar, 1911, Bullen and Lamb, CVA #St Pk P271.2*

STANLEY PARK COUGAR

On October 5, 1911, the Stanley Park superinten-
dent discovered that a stag had been killed in the
zoo. At first, he thought it was the outcome of a
stag fight since it was mating season, but the killer
returned the following night to feast on the car-
cass, and later that week goats were mysteriously
dying.

Someone reported having seen a bear swim
across the Second Narrows, but "nature experts"
determined that a cougar, not a bear, was on
a killing spree. Vancouver police officers were
recruited to hunt the killer but found no trace of
the animal, and that night more goats were killed.
Next, a big-game hunter and his specially trained
cougar-hunting dog tried, again without success,
to track down the predator. But based on tracks
he found, the hunter figured that the suspect was
a large cougar.

After a 125-lb (57-kg) buck was slaughtered,
the experts concluded the killer must weigh at
least 250 lb (113 kg). The *Province* offered fifty

dollars to whoever delivered the cougar's dead
body to its Hastings Street office. With the reward
as an incentive, three Cloverdale hunters and
their foxhounds came to Stanley Park. These men,
according to the *Province*, "were of the type which
we in Vancouver know too little about—the men
who live near to nature."

The hunters set out early on October 26 and
swore they'd get the cougar by four p.m., "or
we'll know that he isn't in the park." They shot
the cougar near Beaver Lake, six minutes before
four. The wounded beast fled but was soon redis-
covered forty feet (twelve metres) up a hemlock
tree, glaring down at the barking dogs. After a
few more shots, the dead cougar thudded to the
forest floor.

It turned out to be a 137-lb (62-kg) female
cougar that caused all the fuss. The *Province* had
it stuffed and displayed it in its storefront window
and later returned it to the park to display in the
Stanley Park Pavilion.

HELENA GUTTERIDGE

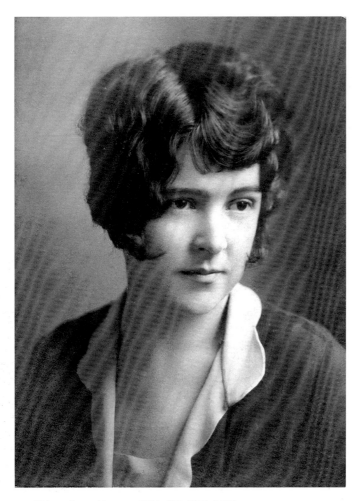

57 Helena Gutteridge, ca. 1911, CVA #371-2693

After cutting her political teeth in the British suf-fragette movement, Helena Gutteridge moved to Vancouver in 1911 and went to work as a tailor, feminist, and labour organizer. In the 1930s, she was the first woman elected to city council, and she spearheaded Vancouver's movement for social housing that continues today.

One of Gutteridge's early projects was the Women's Employment League. Its aim was to help unemployed women make ends meet at least over the Christmas shopping season during a bleak economic period. The League managed to cajole a $2,000 start-up grant out of city hall in the fall of 1914.[110] They rented Carvel Hall, a large house at 1027 Robson Street. It provided accommodation for about fifty homeless women and was converted into a toy-making factory where unemployed women could earn money. The women made dolls, often with a military theme, such as Red Cross nurses and soldiers, as well as doll houses. Other toys included "Belgian dog-carts, miniature battleships, aircraft, and all the panoply and paraphernalia of war." The women also made up war-themed games with names such as "Shoot the Kaiser." Workshops were held at Carvel Hall to teach the women dressmaking and millinery skills. They made puddings, cakes, and other sweets for sale and offered stenography and other clerical services.[111]

More than 800 women registered with Carvel Hall, although there was space for only 150 in the program.[112] The League also helped about 500 women find work, mostly as domestics, and others to find lodging elsewhere in the city. Dolls and other toys were sold at booths set up on Granville and Hastings Streets, and the White Sewing Machine Company donated space in its Granville Street storefront. Just before Christmas, the leftover inventory was auctioned off. The proj-ect was a success, but petered out the next year as the economy improved and the six-month lease expired.[113]

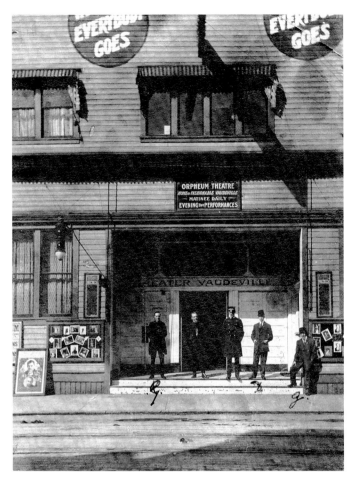

58 *Orpheum Theatre, 805 West Pender Street, 1910, CVA #Bu P440*

CHARLIE CHAPLIN

Charlie Chaplin first came to Vancouver for a week-long engagement at the Orpheum Theatre with the Fred Karno London Company in May 1911 while touring the Sullivan and Considine vaudeville circuit, which operated the Orpheum chain in the west. The show was immensely popular and, although he wasn't billed until later in the tour, Chaplin clearly stole the show, according to the *News-Advertiser*:

> The much heralded act, "A Night in an English Music Hall," was the reason for the crowded houses at the Orpheum Theatre yesterday. Such laughter as greeted it has not been heard for a long time. The chief cause of their amusement, and the one to whom all the honors go, is Charles Champlin [sic], who plays the part of the inebriated swell. During the whole action he does not say a single word, but expresses himself in pantomime. His gestures, his facial expression as the various artistes appeared in their turns, and his approval or disapproval of the same, all are inimitable, and evokes roars and roars of laughter. The wrestling bout at the finish, in which he bests the "Terrible Turk," is the best of all, and brings the offering to an enjoyable conclusion.[114]

The show toured down the coast then back east before returning to Vancouver the following April.

Vancouver apparently didn't make a huge impression on Chaplin. At the time, he was actively embracing his new life in the US, where the rigid English social structures didn't limit opportunities for a working-class kid in show business. In his autobiography, Chaplin recalls: "In Winnipeg and Vancouver, audiences were essentially English and in spite of my pro-American leanings it was pleasant to play before them." In contrast, his next paragraph begins: "At last California!"[115]

Director Mack Sennett made a mental note of the talented performer playing the "inebriated swell" during a New York performance between the two Vancouver dates on the tour. A couple of years later, Sennett started Keystone Studios and lured Chaplin away from Karno with a lucrative contract.

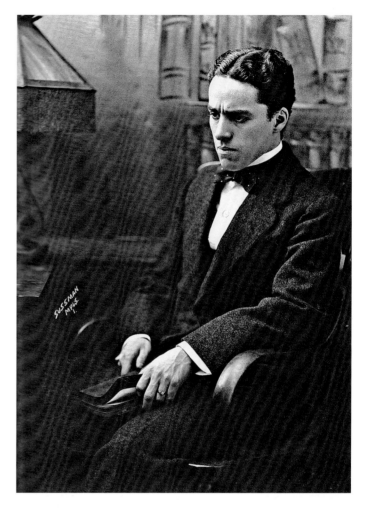

59 *Charlie Chaplin during the 1911 Karno tour, Sussman Photo Studio*

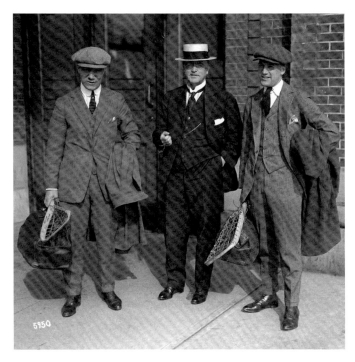

60 *Newsy Lalonde, Con Jones, and Leo Dandurand, 1912, Stuart Thomson, VPL #35177*

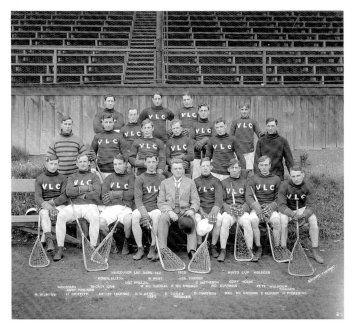

61 *Con Jones (centre) with the Vancouver Lacrosse Club, 1912, CVA #99-43*

CON JONES

Con Jones came to Vancouver from Australia in the early 1900s. He opened a chain of billiard halls/tobacco shops. His advertising slogan was "Don't Argue—Con Jones sells fresh tobacco," accompanied by a vaudevillian image of one man pushing another. These signs were a familiar sight around town, and could also be found on tokens, match boxes, and other products sold in his stores.

Jones was also a major sports (particularly lacrosse and soccer) promoter in Vancouver. Callister Park on Renfrew Street was once owned by and named after Jones and was the city's top soccer field. In the 1910s, at a time when lacrosse was far more popular and lucrative than hockey in Canada, Jones was determined to bring the Minto Cup to Vancouver. He succeeded, and in 1911 Vancouver won both the Minto and Mann Cups (awarded to Canada's top junior and senior Men's lacrosse teams, respectively), in part because Jones had used buckets full of money to lure top players from the east, including hockey legend Newsy Lalonde. However, the Vancouver Lacrosse Club's momentum faded after a few years, and the New Westminster Salmonbellies returned to its dominant position in the league.

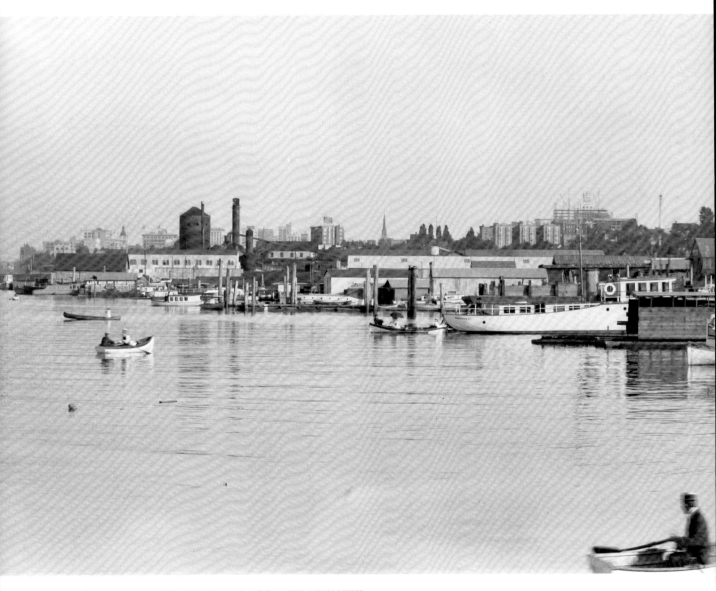

62 *Denman Arena, 1913, W.J. Moore, detail from CVA #PAN NXVII*

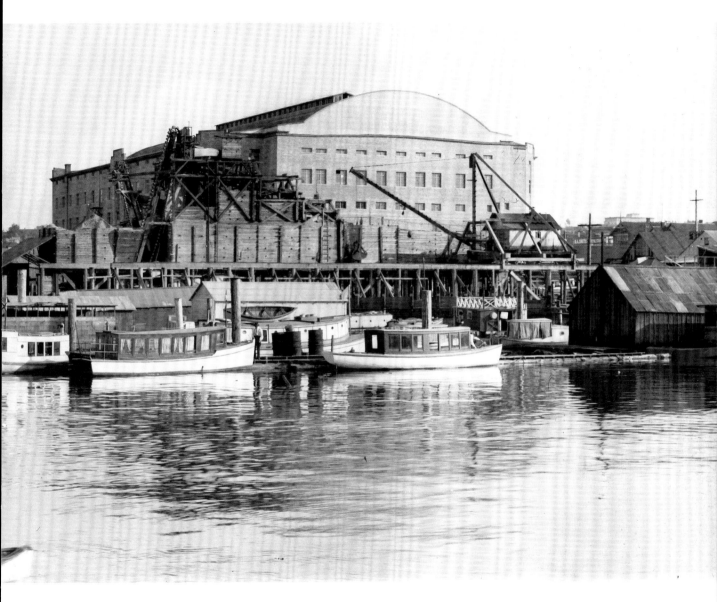

DENMAN ARENA

Vancouver's hockey history began in 1911 when the Denman Arena was built at Denman and West Georgia Streets. Because of the city's moderate climate, even in winter there were no natural ice surfaces on which to learn to skate and play hockey. Frank and Lester Patrick, professional hockey brothers from Quebec, came west to remedy the situation. Using money from their father's lumber business, the brothers founded the Pacific Coast Hockey Association and built arenas in Vancouver, New Westminster, and Victoria to support the league. The Denman Arena was Canada's first indoor ice rink, and with a capacity of more than 10,000 was the second-largest indoor sports facility after New York's Madison Square Gardens. The arena was home to the Vancouver Millionaires, which won Vancouver's first and only Stanley Cup there in 1915. The Denman Arena burned down in 1936.[116]

DORA DEAN & CHARLES JOHNSON

Dora Dean and her husband Charles Johnson were one of the most successful African-American vaudeville acts in their day. They were known for pioneering the Cakewalk, being the first African-American couple to perform on Broadway (breaking the convention of male-male comedy duos), and adding metal plates to tap shoes. Johnson and Dean bucked racist expectations by being a "class act," known for wearing very expensive formal attire. The legendary Bert Williams even wrote a hit song about Dean ("the sweetest gal you ever seen"). She was a "Sweet Cap Girl" in England (a photocard of her was included with packs of Sweet Caporal cigarettes) and appeared in several movies.

This publicity photo was given to the manager of Vancouver's Orpheum Theatre when Dora Dean brought her "Fancy Fantoms" there in 1914. Johnson and Dean had split up earlier that year, but reconciled in the 1930s.

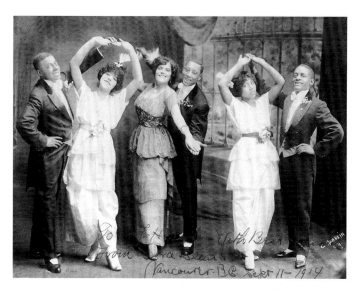

63 *Dora Dean (third from left) and her Fancy Fantoms, 1914, G. Dobkin, CVA #371-2165*

THE ORIGINAL CREOLE ORCHESTRA

The Original Creole Orchestra is widely considered to be New Orleans' first jazz export. They played Vancouver's Pantages Theatre in 1914 on a vaudeville bill alongside a musical play, The Irish Chatterbox, a roller-skating duo, and a couple performing "neat and eccentric, grotesque singing and dancing." The brief review in the *Vancouver Sun* said the Original Creole Orchestra "drew forth appreciative applause ... their singing of the old Southern melodies being especially fine."[117]

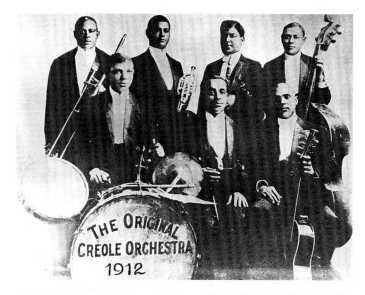

64 *Original Creole Orchestra, Louisiana Digital Library #1979.89.7339*

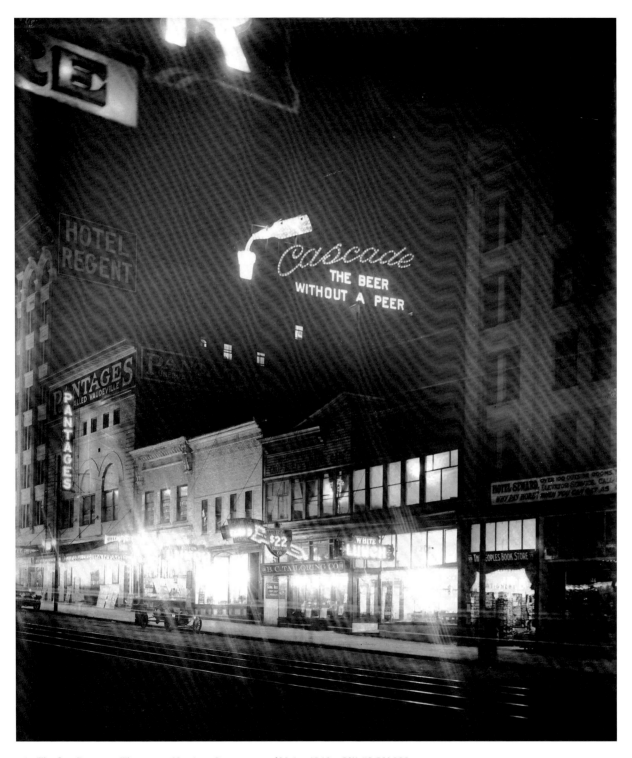

65 *The first Pantages Theatre on Hastings Street, west of Main, 1910s, CVA #LGN 999*

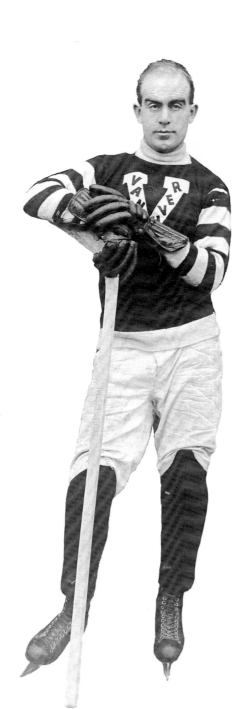

FRED "CYCLONE" TAYLOR

Fred Taylor, who grew up in Listowel, Ontario, was Canada's first hockey superstar. He got the nickname "Cyclone" after Lord Grey watched him score five of Ottawa's eight goals in a 1907 game and remarked, "[T]hat boy Taylor is certainly the greatest cyclone on ice I ever saw."[118] Taylor was recruited by his former teammates, the Patrick brothers, to play on their newly minted Vancouver Millionaires team in the Pacific Coast Hockey Association. By the time he arrived in Vancouver in 1911, he already had a Stanley Cup under his belt from playing for Ottawa.[119] In the 126 games he played with the Millionaires, Taylor scored 148 goals, including seven in the game that won them the Stanley Cup in 1915.[120]

Taylor's day job was working as an immigration official, becoming Commissioner of Immigration for BC and the Yukon. In 1914, he found himself on the front lines of an international incident unfolding in Vancouver harbour. Taylor had to inform the crew and passengers of the ill-fated *Komagata Maru* that they were not permitted to disembark. The ship contained 374 Punjabi refugees challenging Canada's racist "continuous journey" law that was designed to keep Indian immigrants out of the country even though they were British subjects. "Well, they darn near took the boat apart right there," Taylor later recalled.[121] "They'd curse us and press against us and sometimes fought us off as we came aboard, shouting threats and insults."[122] The incident ended—in Vancouver, at least—two months later when the naval cruiser HMCS *Rainbow* forced the vessel out of Vancouver harbour and back to India.[123]

66 Fred "Cyclone" Taylor, 1919, Stuart Thomson, CVA# 99-778

In 1976, Cyclone Taylor met with ninety-seven-year-old Giani Kartar Singh, the only known surviving passenger from the *Komagata Maru* incident. The two men had an amiable visit, speaking through an interpreter about the passage of time, how much the port had changed since 1914, and Singh's visit with relatives in Vancouver. One thing they didn't talk about was the *Komagata Maru*. "I have completely forgotten that," Singh told reporters for the *Vancouver Sun*.[124]

67 *Fred "Cyclone" Taylor and Giani Kartar Singh, September 17, 1976, Rob Straight*, Vancouver Sun, #76-3170

VANCOUVER PROHIBITION

Temperance advocates spent years pushing for alcohol prohibition in British Columbia, but it was not until World War I that the political scale tipped in their favour. Along with rationing and other measures on the home front, prohibition was essentially part of British Columbia's war effort, and came into effect in October 1917.

Prohibition did not make Vancouver a temperance town, but neither did it have the infamously disastrous effects it did in American cities such as Chicago. There were so many exemptions and workarounds to the law that getting a drink was not much more difficult than before prohibition. Joe Sheftell, the manager of a vaudeville group visiting Vancouver, explained to a Chicago newspaper the most popular method of obtaining booze in Vancouver: "All you have to do up here is to pay fifty cents for a prescription and

[you] get all the liquor you want."[125] Indeed, over 315,000 prescriptions were written in 1919 alone, and some doctors were writing more than 4,000 each month in BC.[126]

Doctors were not the only ones making a killing off prohibition. Vancouver became a major exporting centre for smuggling booze into the United States, which continued long after BC became the first province to repeal prohibition in 1921.[127] Enormous fortunes were made by enterprising brewers cum rumrunners such as the Reifel family, whose local legacy includes the Commodore Block on Granville Street.[128] Bootleggers and "blind pigs" (speakeasies) also fared well under prohibition, but not nearly as well as exporters and, as this 1918 photo (next page) shows, they were the main targets of the police department's Dry Squad.

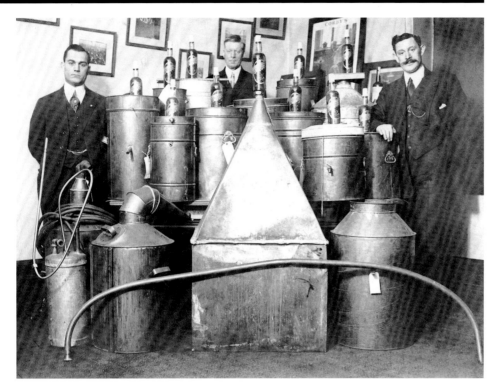

68 *Vancouver Dry Squad, 1918, CVA #480-215*

PATRICIA CABARET

When alcohol prohibition came into effect in 1917, several hotels converted their bars into cabarets featuring live music and dancing, hoping to make up for lost alcohol revenue with a door charge and soft drink and "near beer" sales. City inspector Jones visited a few cabarets in the first week of prohibition and found them to be on the up and up; the Patricia Hotel on Hastings Street had "all the tables taken up and judging from the character of the entertainment I do not think anyone could take objection to it." He also applauded the management's voluntary policy of refusing entry to women without a male escort.[129] "WE ARE CATERING ESPECIALLY TO A FAMILY TRADE," proclaimed an ad for the Patricia Cabaret.[130]

69 *Patricia Hotel, 1917, Stuart Thomson, CVA #99-187*

Other nearby hotels, such as the Bodega, Regent, and Irving, also advertised live music, but the Patricia was the only one to advertise "Real Jazz Band Music." Fear of the "corrupting" influence of jazz apparently didn't impinge on the Patricia's wholesome, family-friendly environment. A newspaper editorial from October 1917 argued that jazz was a legitimate musical genre that was simply misunderstood: "The number of musicians that can jazz properly is said to be small, because it really requires good musicians who must also be endowed with the swing or knack of performing it ... Jazz music is rhythmical and inspiring. It is declared the best antidote for the blues."[131]

The Patricia recruited George Paris (p. 62) to play and book music at the new cabaret. Paris was well-known in the city for his involvement with sports, but he was also a jazz percussionist. His exposure to jazz first occurred when he accompanied heavyweight boxing champion Jack Johnson (p. 64) on a European tour. (Johnson opened the Harlem nightclub that evolved into the famous Cotton Club.)[132] In November 1918, a fellow musician referred to Paris, then playing at a club called the Hole in the Wall,[133] as "the king-pin of the drummers." By 1919, however, when another jazzman named Will Bowman was operating the Patricia Cabaret, it seems to have become slightly less wholesome.

JELLY ROLL MORTON

Jazz pianist and composer Jelly Roll Morton may have exaggerated his role in the development of jazz, but he was definitely a product of the Storyville scene in New Orleans that gave birth to the genre, and he certainly made an important contribution. In 1919, Jelly Roll was invited to join the house band at the Patricia Cabaret under its new manager, Will Bowman. A railway porter named Edward Rogers wrote to the *Chicago Defender* with a brief update on the Vancouver scene: "Well, Will Bowman has opened a cabaret here and is doing fine. He has an eight-piece jazz band with Oscar Holden, Leo Bailey, Jelly Roll, Ada Brick-top Smith and others, with Mrs E.T. Rogers cashier. Tom Clark has a neat little café, Reg Dotson still has the Lincoln club, Jean Burt and Perkins have opened a nite club and café, so Grandell [Granville] street looks like some parts of the Stroll [the nickname for Chicago's jazz strip]."[134]

Jelly Roll Morton didn't stay long at the Patricia. Years later, he explained that, "I had good men, but somehow that cabaret didn't do so good. Folks there didn't understand American-style cabarets."[135] But after Morton left the Patricia and toured down the coast, he then came back to form the house band at Patty Sullivan's club at 768 Granville Street.[136] Sullivan was a big-time gambler who took Morton along on gambling excursions "as a front man." Morton claimed that when he left Vancouver, he spent all his gambling winnings on diamonds and travelled all summer with them pinned to his underwear.[137]

70 *Jelly Roll Morton (back right) recording at RCA, 1939, Louisiana Digital Library #1978.118(B).00581a*

Reports in the *Chicago Defender* contradict Morton's claim that the Patricia didn't do well after he left. One article from the summer of 1920 said that, "Word comes from Vancouver, BC, that Bill Bowman's Patricia Café is the talk of the town."[138] In January 1921, L. Louis Johnson wrote that "Bowman is proprietor of one of the largest and finest cabarets in all Canada, and Oscar Holden, his business associate, has charge of the ten piece orchestra—the best I ever heard. Vancouver's best people patronize the splendid place, and they turn 'em away nightly."[139] By 1922, prohibition was over and Will Bowman and Oscar Holden were cultivating Seattle's jazz scene, Jelly Roll had gone to Alaska, and Ada "Bricktop" Smith (opposite) was destined for Paris.

ADA "BRICKTOP" SMITH

Ada "Bricktop" Smith was a singer and dancer
from Chicago who spent 1919–20 in Vancouver
performing at the Patricia Cabaret. Bricktop
was notable for a number of reasons, the least of
which was her singing. After leaving Vancouver,
she spent some time in Harlem, where she per-
suaded a club owner to give Duke Ellington his
first major gig. Then she went to France and
became the doyenne of Paris's café society, its
expat American "lost generation" of writers, art-
ists, and musicians. Smith taught Cole Porter
and his friends how to dance the Charleston and
the Black Bottom, and he helped her set up Chez
Bricktop, one of Europe's top jazz-age nightclubs.

One time, Bricktop threw John Steinbeck out
of her club for "ungentlemanly behaviour," for
which he apologized by sending her a taxi filled
with roses. Django Reinhardt wrote his song
"Bricktop" about her, and Cole Porter wrote "Miss
Otis Regrets" for her. T.S. Elliot wrote a poem
about her, and F. Scott Fitzgerald once said his
biggest claim to fame was that he discovered
Bricktop before Cole Porter did.[140] But before all
that, Bricktop was living in Vancouver and sing-
ing at the Patricia.

The *Chicago Defender* was an African-
American newspaper that served as a social net-
working tool for vaudevillians, musicians, railway
porters, and others on the road. On February
14, 1920, it published an update on Bricktop
from Vancouver. She was doing fine, but had had
"the misfortune of breaking one of her limbs on
Christmas Eve after a lengthy visit to someone's
cellar, but the break is mending rapidly and she
will soon again be able to strut her stuff with
her usual vim and pep."[141] In her autobiography,
Smith recalled that her leg was broken in a bar-
room brawl that erupted among the Scandinavian
loggers who frequented the Patricia.[142] She also
told the *Defender* that her mother would be
spending the summer with her in Vancouver and
that letters could be sent to 848 East Georgia
Street.

71 *Ada "Bricktop" Smith in Paris, 1934, LoC #LC-USZ62-99870*

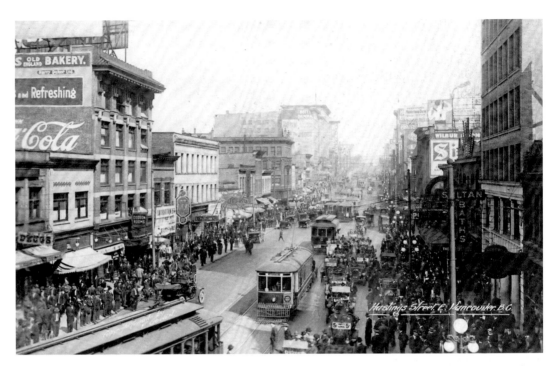

72 *Jitneys and streetcars on Hastings Street, 1917, Frank Gowan, CVA #677-953*

JITNEYS & STREETCARS

Jitneys first appeared on Vancouver streets during World War I. They were cars that operated like buses, with fixed (yet flexible) routes, multiple passengers, and a flat fare of five cents ("jitney" was slang for a nickel). Although they looked more like taxis, jitneys were the forerunner to the city bus. Not surprisingly, the monopolistic BC Electric Railway Company (BCER) felt threatened by the jitneys, which reduced ridership on their streetcars. The BCER was forced to compete with the convenient service offered by jitney operators, whose overhead costs were far lower.

Initially, the BCER argued that jitneys weren't economically sustainable once maintenance and liability costs were accounted for. To test this theory, they secretly operated three jitneys in the winter of 1914–15, but found that a jitney operator could eke out a living comparable to a factory worker.[143] However, the profitability of jitneys was whittled away by taxes, licensing, and other fees gradually imposed by the city, and they were ultimately banned.

Jitneys played a role in the city's industrial relations. The head of the BCER blamed a 1917 streetcar workers' strike on competition from jitneys, which, he said, destabilized the transit industry and made it impossible to meet wage demands.[144] During the 1919 general strike, jitneys were reintroduced in order to undermine the street car workers' part in the action. In 1933, Vancouver Mayor L.D. Taylor averted another strike by threatening the head of the BCER that the ban on jitneys would be lifted unless management got back to the bargaining table and started making some concessions to the union.[145]

73 *Fountain Chapel, courtesy of John Atkin*

THE FOUNTAIN CHAPEL

After a black man named Robert Tait killed Vancouver's chief constable in 1917, police began discriminatory racial profiling and many employers refused to hire blacks. This backlash may have been the catalyst for the city's small black community to buy, for their own use, an old Scandinavian church at Jackson and Prior Streets, near the train station, where many black men worked as railway porters.[146] According to Nora Hendrix (Jimi Hendrix's grandmother, who lived in Vancouver), the city's black population had worshipped in local halls before they had their own church. The Fountain Chapel, a chapter of the African Methodist Episcopal Church (AME), opened in 1918.[147]

It became an important community space for local blacks. There were bars and clubs in the city that catered to a black clientele, but the chapel was the only place open to the entire community, including teetotallers and children. In the 1930s, an influx of African-Americans in Vancouver increased the number of black families in the area.

The alley west from Fountain Chapel to Main Street became known colloquially as "Hogan's Alley."

The little church played a significant role in two criminal cases involving black men. After Fred Deal, a black man, killed a police constable in 1922, parishioners and community members mobilized to ensure the trial was not tainted by racism. The accused was sentenced to the gallows, but after a retrial (and perhaps thanks to the legal support provided through the chapel), he was given a life sentence.[148] In the 1950s, the church lobbied for an inquiry when Clarence Clemons, a black longshoreman, died after being beaten by the police.[149]

The black community dispersed after the Georgia Viaduct was built through their Strathcona neighbourhood in the early 1970s, and the AME sold Fountain Chapel in the 1980s. The building still stands, but is now privately owned.

JAMES SHAVER WOODSWORTH

After losing his government job in Winnipeg for being a pacifist during World War I, James Shaver (J.S.) Woodsworth came to Vancouver, rented a room at 1218 Howe Street, and found work on the docks. Back home he was known as a prominent minister and social reformer devoted to improving conditions for the poor urban immigrants he called "strangers within our gates."[150] But in Vancouver he kept his past—and his fancy Oxford education—to himself, hoping to blend in with the other stevedores.

"Being a town-bred boy and having gone through school and college into professional life, I had never done manual work," he confesses in *On the Waterfront*, a booklet (not the more famous movie) describing his experience working in one of Vancouver's most important industries. In it, Woodsworth introduces us to some of the characters he worked with, the "men without a country" who found themselves "in war time marooned on the shores of the Pacific."[151]

Wordsworth found longshoring physically demanding and monotonous. Job security was non-existent, and working conditions were generally grim, even though this was one of the more coveted manual labour jobs at the time. *On the Waterfront* is an exposé of the plight of the working class and an outlet for Woodsworth's developing socialist ideas.

J.S. Woodsworth returned to Winnipeg in 1919 and was arrested for his involvement in the general strike there. He was later elected to the House of Commons, where he argued successfully for the introduction of old-age security legislation, the first substantial component of Canada's social safety net. In 1932, Woodsworth and other democratic socialists formed the Cooperative Commonwealth Federation (the precursor to the New Democratic Party), which he led until World War II.

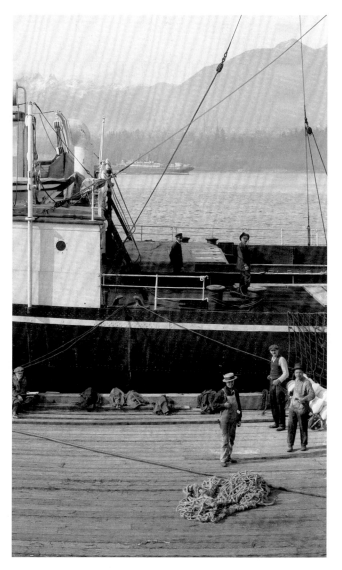

74 *James Shaver Woodsworth, 1921, LAC #C-057365*

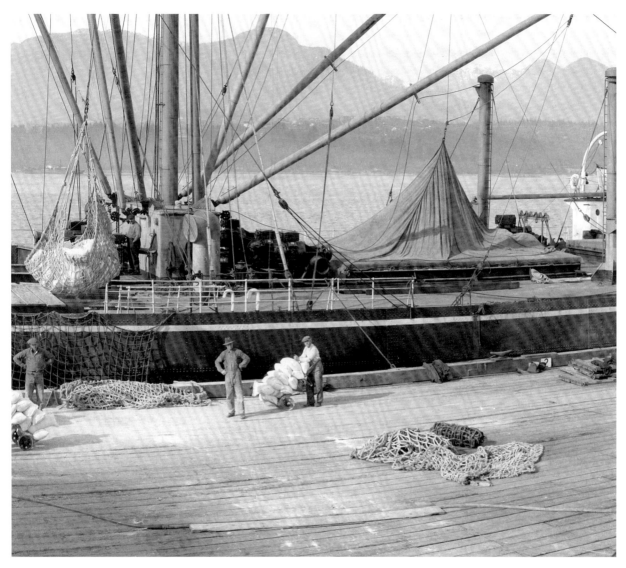

75 *Longshoremen, 1924, W.J. Moore, detail of CVA #PAN N203*

76 *Longshoremen at work, ca. 1930, James Crookall,*
CVA #260-317

THE "HUMAN FLY"

Harry Gardiner was a stunt man who earned his living throughout North America and Europe by climbing tall buildings without special gear, aside from his highly developed fingers.[152] As part of the Victory Loan drive to raise funds for the war effort, the "Human Fly" climbed the Hotel Vancouver and then, a few days later, the World Building (now the Sun Tower, on West Pender Street). He wore white so he would be visible to the "seething solid mass of humanity" that came out to watch. After each climb, Gardiner appealed for the crowd to buy Victory Bonds.[153]

Harry Gardiner was probably the best known "Human Fly," but he wasn't the only one in this pioneering age of the publicity stunt. The attraction was that the danger was real, and occasionally thousands of spectators witnessed a daredevil plummet to his death.[154] Another danger was the deadly influenza epidemic that was in full swing when Gardiner came to Vancouver. Indoor mass gatherings had already been banned, and doctors reported that there were noticeable increases in flu cases after Gardiner's climbs.[155]

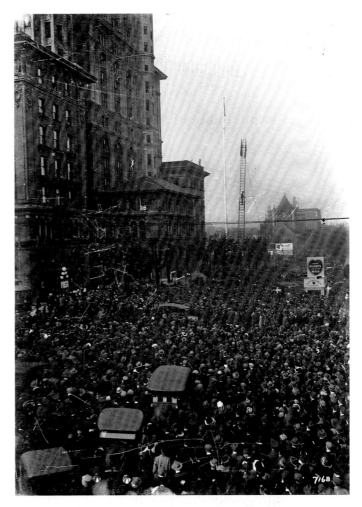

77 *Harry Gardiner climbing the Hotel Vancouver, 1915, Stuart Thomson, VPL #18338*

78 *Harry Gardiner climbing the World Building (now Sun Tower), 1918, CVA #Bu P734*

79 *Trotsky at the Stanley Park Zoo, 1920s, CVA #371-2843.1*

TROTSKY THE BEAR

In 1918 and 1919, Canadian and other allied forces got a head start on the Cold War by fighting the Reds in Siberia. The troops withdrew in 1919 and brought back to Canada an enormous bear as a souvenir for the Stanley Park Zoo. Naturally it was named Trotsky, and for twenty years the good-natured beast charmed park visitors as the zoo's most popular attraction. At more than 520 lb (236 kg), the great Russian bear was thought to be the largest in captivity.[156] Trotsky the Bear was so well-known that, when he died in 1939, it was reported in the *New York Times*.[157]

80 *Dr Crapo, July 23, 1922,* Vancouver Sun

DR CRAPO

Dr Joseph Edwin Crapo was a chiropractor, vaudevillian, and artist's model. In 1915, he won one of the first Mr America-type bodybuilding competitions. He lived most of his life in California, but was based in Vancouver in the early 1920s.

The *Sun* reported that Dr Crapo amazed a crowd of hundreds at a demonstration with remarkable feats of strength, including withstanding a man jumping from a height of ten feet (three metres) onto Crapo's rock-hard stomach.[158] But the most "outstanding" display, according to the *Sun*, was the bodybuilder's poses. Clad only in leopard-skin shorts, Crapo tensed all of his muscles so that they "rippled under his skin like a torrent in a mountain stream."[159]

RACE ACROSS CANADA

Terry Fox may be the most well-known person to attempt to traverse the long distance between Vancouver and Eastern Canada on foot, but the feat goes back at least to the 1860s, when Maxie Michaud walked from Montreal to Vancouver, where he became Burrard Inlet's first postmaster.[160] The challenge was taken up again in 1921 by a group of Haligonians. Nineteen-year-old Charlie Burkman decided to make the trip from Halifax to Vancouver on foot and teamed up with the *Halifax Herald* to share his adventure with its readers. Burkman's partner on the trek, Sid Carr, bailed on him in New Brunswick to become a rumrunner, so Burkman made most of the journey alone.

Some other folks took Burkman's trek as a challenge. Husband-and-wife team Jenny and Frank Dill and Jack Behan and his son Clifford turned it into a transcontinental foot race. Although Burkman was already well on his way when the other teams began, they were convinced they could make the long journey in less time. The teams travelled mostly along railroad tracks. Between Sudbury and Moose Jaw, Burkman used a pair of modified roller skates to roll along the tracks, pushing himself forward with a pole.[161]

Charlie Burkman arrived in Vancouver first on June 15, 1921, but at 131 days, the Dills had the best time and won the contest. The Behans came in second at 136 days, and poor Charlie finished last at 149 days. All were reported in pretty rough shape by the time they arrived on the coast.[162]

Halifax Hikers At Vancouver

FIVE trans-continental walkers snapped in front of the Vancouver Sun office just before leaving for Montreal. Left to right are Mr. and Mrs. Frank Dill the Behans, father and son, and Charles Burkman.

The Behans arrived in Vancouver first, having completed the journey in 138 days, but the Dills, who were second to arrive, made a record, having walked the 3786 miles in 134 days. Twenty-year-old Burkman took 149 days to make the trip, but he lost several days when his feet gave out, and he also spent three days with his parents in Port Arthur. Burkman claims to have lost 20 days altogether.

Mrs. Dill is continuing to Halifax by train, but her husband plans along with Burkman to compete against the Behans in a walk from Montreal to Halifax. Sydney Carr started from Halifax with Burkman, but quit at Petitcodiac, N. B.

81 *Foot racers in Vancouver, 1921, LAC #NL-22182*

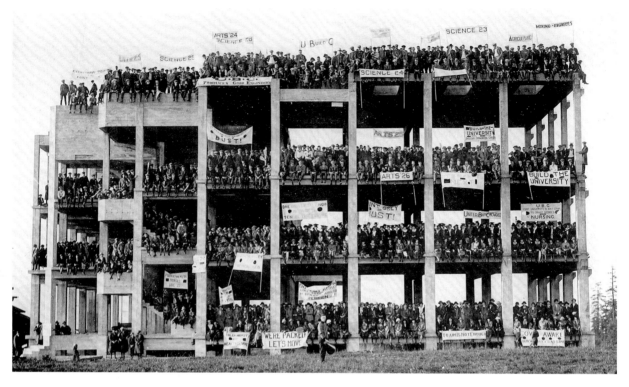

82 *The Great Trek at the science building, 1922, UBC #1.1/1315*

UBC'S GREAT TREK

Overcrowded and inadequate facilities at the University of British Columbia's temporary quarters at its Fairview neighbourhood "shacks" prompted students to stage a publicity campaign in 1922 to convince the government to resume construction on the new Point Grey campus. The campaign culminated on October 28, 1922 in what has become known as the Great Trek. The student body of some 1,200 marched through downtown Vancouver with banners and floats and then out to the tip of Point Grey where they climbed into the framework of the unfinished science building. Public support rallied by the campaign persuaded the government to resume work on the UBC campus, which finally opened its doors in 1925.[163]

83 *Babe Ruth, Chief Constable Long, and Vancouver mayor L.D. Taylor at the Pantages Theatre, 1926, CVA #1477-107*

BABE RUTH

Babe Ruth came to Vancouver at the height of his baseball career for an appearance at the second Pantages Theatre. Ruth's visit was part of a series of big sports names at the theatre, including former heavyweight boxing champions "Gentleman" Jim Corbett and Gene Tunney, and boxer/actor Georges Carpentier. A Pantages newspaper ad claimed that the theatre had lost money bringing these celebrities to town, but in the long run, they would help to make the Pantages circuit "the foremost in vaudeville entertainment."[164]

A.D. "COWBOY" KEAN

A.D. "Cowboy" Kean was a rodeo cowboy, photographer, filmmaker, and writer. His subjects tended to be rodeos, trappers, ranchers, Mounties, and other staples of Canadiana.[165] Kean moved to Vancouver after his last professional rodeo cowboy gig at the 1912 Calgary Stampede. He produced a number of films for the provincial government before embarking on his most ambitious film project, an epic feature-length version of R.G. Macbeth's popular book *Policing the Plains*, in 1927. After it received a lukewarm reception and a limited screening, Kean moved to Toronto where he wrote adventure stories for the *Toronto Star* and became a broadcaster on CBC radio.[166] Most of his films, including *Policing the Plains*, have not survived.

84 *Mounties leaving the courthouse in* Policing the Plains, *A.D. Kean, 1924, BCA #H-01267*

CHARLES "DAD" QUICK

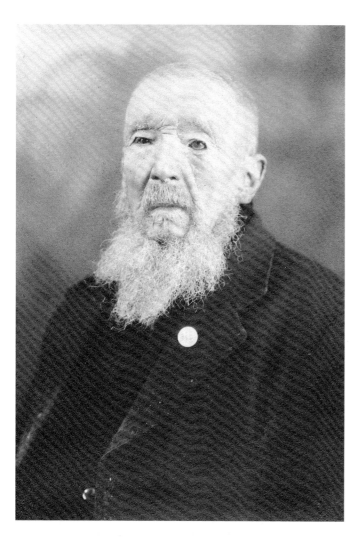

Charles "Dad" Quick was already a local celebrity when he died in Vancouver on May 10, 1932 at the age of 111, making him the oldest person in Vancouver at the time, and probably in all of Canada, if his claimed age was accurate.[167] "I only went to two schools," he told a newspaper reporter in 1931, "my mother and the world."[168]

Perhaps Quick's biggest claim to fame came from his association with Elias Howe, the inventor of the modern sewing machine, whom he worked for in the 1840s. Quick said that he helped Howe make the first six sewing machines, and that it was his idea to put the eye in the pointy end of the needle.[169]

Details of his life are a little sketchy, but apparently Quick fought in the Crimean War and in the American Civil War (on the side of the Union). He had a successful saddle-making shop in Chicago, but lost everything, including a son, in the Great Chicago Fire of 1871. After roaming around the US, Quick finally settled in Vancouver in 1911 and set up his own shop where he worked right up until the end.[170]

85 *Charles "Dad" Quick, 1908, Philip T. Timms, CVA #677-521*

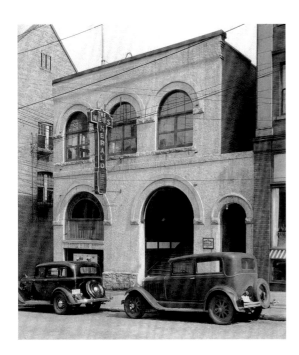

86 News-Herald *building at 426 Homer Street, 1935,*
Stuart Thomson, CVA #99-4742

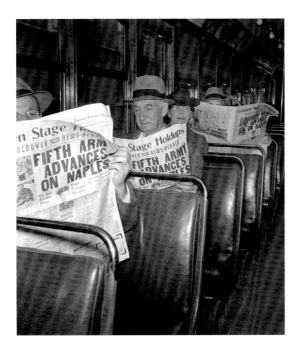

87 *Streetcar passengers reading the* News-Herald, *1943,*
Don Coltman, CVA #586-1551

THE *NEWS-HERALD*

When employees of the *Vancouver Star* voted to
reject a fifteen-percent pay cut in 1932, publisher
Victor Odlum's response was to shut down the
paper. Given the scarcity of employment in the
depths of the Great Depression, several of the
Star's laid-off staff did the unthinkable: they
started up their own newspaper, the *Vancouver
News-Herald.* Vancouver already had two other
daily newspapers, the *Sun* and the *Province*, but
what made the move truly bold was that the new
paper would be controlled by the workers.[171]

Forty people signed on to work at the *News-
Herald*, including James Noel Kelly as editor.
Twenty-one-year-old Pierre Berton was hired
as the city editor, the youngest in the country.
The group managed to raise $5,000, and spent
$1,100 on a vintage printing press. The editorial
and business staff worked in one building, the
composing room was in the next block, and the
printing press was outside the city. Nevertheless,
they managed to sell enough advertising to launch
the paper.[172]

The *News-Herald* debuted on April 24, 1933;
the printing press malfunctioned from the start,
so staff cranked it out by hand. Initial circulation
was 10,000 and reached 40,000 at its peak—well
below that of its rivals, but enough to keep the
business afloat and eventually move into its own
building at 426 Homer Street.

The workers' cooperative business model
worked until the end of the Depression when
D.A. Hamilton rescued the *News-Herald* from
bankruptcy and became its publisher (although
staff remained shareholders).[173] Media mogul
Roy Thompson bought it in the 1950s and shut it
down in 1957, after twenty-four years in business.

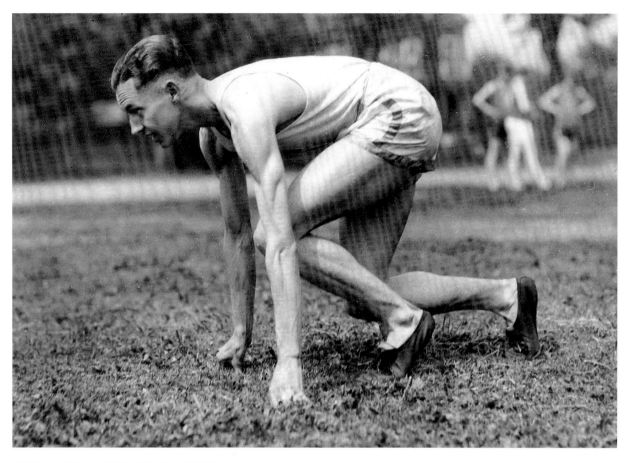

88 *Percy Williams, 1928, CVA #Port P627.2*

PERCY WILLIAMS

Twenty-year-old Percy Williams came out of nowhere to win gold medals for Canada in both the 100- and 200-metre sprints at the 1928 Amsterdam Summer Olympics. He went on to win gold at the inaugural British Empire Games in 1930. In the same year, he broke the world record at the Canadian Track and Field Championships with a time of 10.3 seconds in the 100-metre dash, officially making him the fastest man alive. His record held for eleven years.

Williams took up running, despite a heart condition, in 1924 when he was a student at Vancouver's King Edward High School. At just five-feet-six-inches (168-cm) tall and 126 lbs (57 kg), the sickly and slightly built teenager seemed an unlikely candidate for the top rank in any sport, but within a few years he was well known in BC for routinely winning track events throughout the province. On the world sports stage, however, he was unknown and no one expected

JIMMY MCLARNIN

Future boxer Jimmy McLarnin grew up at 662
Union Street in Vancouver's East End. "Our street
was ... not far from the docks," he told *Maclean's*
magazine in 1950. "Some people would call it a
poor street, and some people would call it a tough
street, but to me it was a good street because
there was always something going on."[176]

When he was thirteen, a former professional
boxer in the neighbourhood named Pop Foster
witnessed McLarnin get into fisticuffs with
another boy and recognized his talent. Foster
approached Jimmy's father and promised to make
him a champion. "A champion of what?" Sam
McLarnin queried. "A champion of the world,"
replied Foster.

Fourteen years later, Jimmy "Baby Face"
McLarnin knocked out Young Corbett III just two
minutes and thirty-seven seconds into the match,
making him the Welterweight Champion of the
World. He lost and regained the title the follow-
ing year, and lost it for good in 1935. He retired
in 1936 with a career record of sixty-three wins,
eleven losses, and three draws.[177]

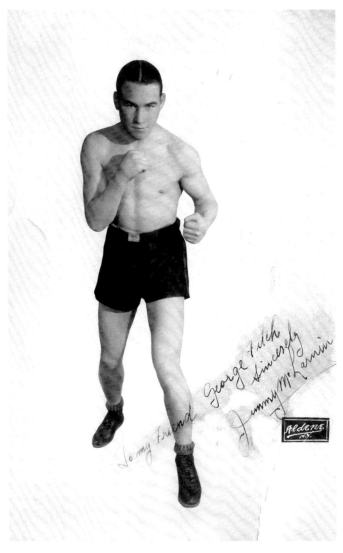

89 *Jimmy McLarnin, 1935, CVA #1088-17*

him to win a gold medal, let alone two, when he
competed against the fastest runners in the world
at Amsterdam.[174]

Back in Vancouver, Williams received a hero's
welcome. He was driven through the streets and
around Stanley Park to the cheers of 30,000
Vancouverites, including 2,500 schoolchildren,
and he received kudos from the Premier, Mayor,
and other officials.[175]

BOB BOUCHETTE

Bob Bouchette was the *Vancouver Sun*'s most popular journalist in the 1930s. His colleague at the paper, Pierre Berton, described him as an iconoclast for such quirky behaviour as interviewing the loser of a boxing match while other reporters scrambled for a sound bite from the winner. A bartender at Bouchette's watering hole on Hastings Street (today called Funky Winker Beans), recalls being told not to wake Bouchette if he saw him snoozing at the bar because "he was writing a column." The same bartender remembers a story about Bouchette swimming across Burrard Inlet to his West Vancouver home with a bottle of rum tied around his neck.[178]

In 1934, Bouchette dressed up like a hobo and went undercover in the relief camps for the unemployed that had been set up around the province. The result was a six-part series of articles that gave his readers an intimate glimpse into the abysmal conditions in the camps, which helped raise public sympathy for the plight of the unemployed.[179]

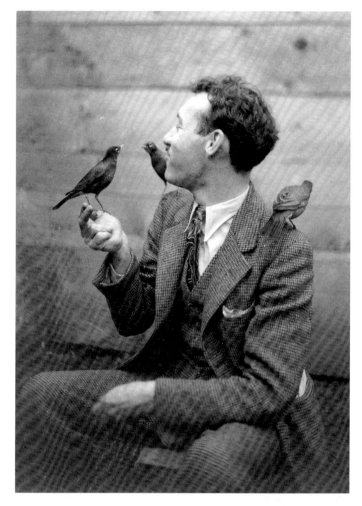

90 *Bob Bouchette at the Birds' Paradise, 1934, CVA #371-1268*

THE BIRDS' PARADISE

The Birds' Paradise was an aviary at the home of
Charles E. Jones at 5207 Hoy Street. Thousands
of birds of thirty-five different wild and domestic
species lived in the sanctuary and gladly posed
with visitors, children, dogs, and even politi-
cians.[180] Following the death of Mayor Gerry
McGeer midway through his term in 1947, Jones
won the mayoral election, but died himself later in
the year.

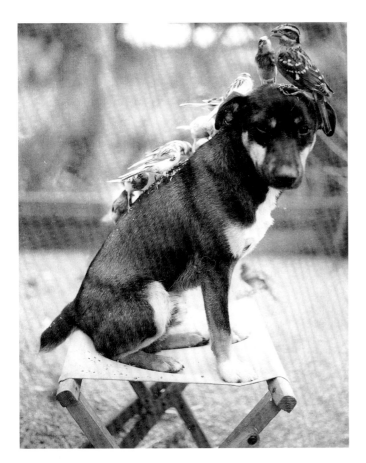

91 *Charles E. Jones's dog Smoky, ca. 1935, CVA #371-1201*

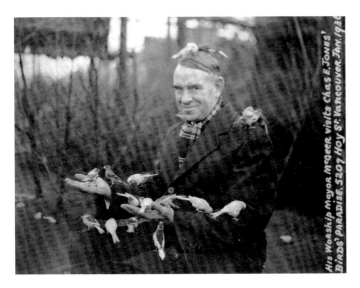

92 *Mayor Gerry McGeer, 1936, CVA #Port P138*

THE O'BRIEN SISTERS

The On to Ottawa Trek began as a two-month-
long protest in Vancouver by a couple thousand
unemployed men on strike from the relief camps
set up and run by the military throughout
Western Canada. On June 3, 1935, the strikers
decided they had accomplished all they could in
Vancouver and hopped onto boxcars at the foot
of Gore Street headed for Ottawa to pressure the
feds to do something about the unemployment
crisis. The Trek was violently crushed in what
became known as the Regina Riot. Although the
effort failed, the Trekkers were successful in gar-
nering public support and ultimately set the tone
for Canada's social safety net after the war.

What makes this image unique is that while
women's role in the movement was largely limited
to maternal-feminist activities such as supplying
food, raising funds, and finger-wagging at politi-
cians, the O'Brien sisters joined the mass of male
protesters attired in what the newspaper caption
calls "their mannish best." Unfortunately, we
know nothing else about "the pretty O'Brien sis-
ters from Vancouver," such as their motivations,
how far they travelled on the trek, or their per-
sonal economic circumstances.[181]

93 *Vancouver's O'Brien Sisters, June 11, 1935*, Ottawa Citizen

94 *Waiting for Lefty at the Dominion Drama Festival, 1936, Yousuf Karsh, LAC # e010752218*

WAITING FOR LEFTY

The 1935 Progressive Arts Club production of *Waiting for Lefty* was a surprise runaway hit that turned Vancouver's amateur theatre scene on its head. The agit-prop play toured the Lower Mainland to packed houses and standing ovations before travelling across the country and winning the award for the best English-language play in 1936 at Ottawa's Dominion Drama Festival. Its success was remarkable given that most of the cast and crew were unemployed and had no previous theatre experience.

The Progressive Arts Club was started by civil-rights lawyer and Stanley Park Hollow Tree photographer Garfield King and Vancouver Little Theatre's Guy Glover. King and Glover believed that the workers' theatre movement emerging in New York and Toronto was a refreshing change from the socially irrelevant fare dominating amateur theatre. The story of *Waiting for Lefty* was based on a New York taxi strike and contained themes that resonated with the working-class cast members. It featured techniques, such as planting actors in the audience, designed to blur the "fourth wall" separating performers and audience.[182]

Police tried to shut down the play as Communist propaganda with vulgar language, but to no avail.[183] *Lefty*'s success made it a source of local pride. Even the high-brow audience at the Ottawa festival was impressed. Prime Minister Mackenzie King wrote about it in his diary: "The labour play 'Waiting for Lefty' while extreme, was a true picture of the hard life which men are encountering today, and the kind of thing which is bred therefrom. Parts of the play reminded me very much what I myself witnessed when dealing first hand with industrial disputes some years ago [as Deputy Minister of Labour]."[184]

95 *Tommy Wong and Sky Scout, 1930s, Wynnie Chow, courtesy of Larry Wong*

THE WONG BROTHERS & SKY SCOUT

Inspired by a 1935 *Popular Mechanics* article, seventeen-year-old Vancouver Technical Secondary School student Robert Wong sent away for instructions to build a Pietenpol Air Camper, a single-seat airplane made out of plywood, metal, and fabric powered by an automobile engine. Robert was an aspiring aviator and planned to use the DIY plane to accumulate enough flying hours to qualify for his commercial pilot's licence.

With help from his fourteen-year-old brother Tommy, Robert built the seventeen-foot-long plane in sections in the small apartment they shared with ten other family members at 124 Market Alley. The completed sections were too large for the apartment and had to be kept in the hallway. To power the plane, the boys bought an old Model-T engine from an auto wrecker for twenty-five dollars. The boys enlisted their mother and her friends to sew the fabric onto the wings.

After a year of toiling, the Wong brothers hauled their aircraft down to the Boeing plant on West Georgia Street where they assembled the sections. RCAF Flight-Lieutenant Johnson deemed the plane structurally sound and gave it a CF-BAA designation. The next step was to truck it to the airport on Sea Island. The boys christened their masterpiece "Sky Scout" and took it on its inaugural flight in 1937. The plane cost them only two dollars an hour to fly.[185] It remained operational until 1945.

When they graduated from high school, the Wong brothers sold Sky Scout and moved to Ontario. After serving in World War II, they opened Canada's largest flight training school on Toronto Island.[186]

THE FIELD

In the midst of the Great Depression, City Council freed up eight acres (32,375 sq. meters) of land on Boundary Road near Hastings for unemployed people to grow their own food. The "Field," as it was commonly known, was formerly the grounds of the Old Peoples Home and was divided up into lots large enough to grow food to feed a family. By 1939, eighty-six men were working the Field, many of whom were European immigrants with specialized skills from their home countries. The oldest was a seventy-six-year-old who walked two miles to his plot every day for seven years. Although the secretary of the Field Committee played the role of "head man," everything was run democratically to make sure the walkways were maintained and weeds didn't encroach on neighbouring plots. If someone found temporary employment, the others would make sure his plot was weeded. The beneficiaries "usually [paid] back their debt by hiring a truck for $1.50 a trip to carry manure from the Exhibition stables at Hastings Park."[187]

96 *Community garden, known as the "Field", July 8, 1939*, Vancouver Sun

THE ASAHI BASEBALL CLUB

At the centre of Vancouver's Japantown, or Little Tokyo as it was also called, was the Powell Street Grounds, today's Oppenheimer Park. Anti-Asian racism after World War I was often intense and reached its peak in the 1940s during World War II when Japanese-Canadians were dispossessed of their property, interned, and expelled from the Pacific Coast to internment camps. Under these difficult circumstances, one avenue for relief was baseball, a game the Japanese adopted as their own, in part because it reflected Japanese philosophy and culture; for example, the "duel" between the batter and pitcher was seen to represent a typical contest between two Samurai swordsmen.

Japanese Vancouverites rallied around their own team, the Asahi. "I'm not saying that the Japanese people are baseball crazy," one old-timer said, "but in a certain way they're crazy alright. As long as they see a baseball, they're happy."[188]

The Asahi baseball club started in 1914 and soon became the pride of the Japanese-Canadian community. Players were recruited from all over the Lower Mainland and, by the 1930s, playing for the Asahi was the dream of Japanese boys across Canada. The Asahi first won the Terminal League championship in 1926 and were soon

competing in the prestigious Senior City League. For five years beginning in 1937, the Asahi were at the top of their game as the reigning champions of the Pacific Northwest Championship. Players on other teams tended to be larger and were often harder hitters, but the Asahi players were exceptionally fast and made being closer to the ground an advantage, playing what the sports pages called "smartball," which included the liberal stealing of bases, bunting, and the risky "suicide squeeze."[189]

In contrast to the discrimination the Japanese in Vancouver often faced off the field, no one looked down on the Asahi on the field. Their popularity extended well beyond the Japanese-Canadian community, not just for winning games, but also because they demonstrated discipline, teamwork, skill, and sportsmanship. In 2003, the Asahi team was finally inducted into the Canadian Baseball Hall of Fame, and in 2005 into the BC Sports Hall of Fame. [190]

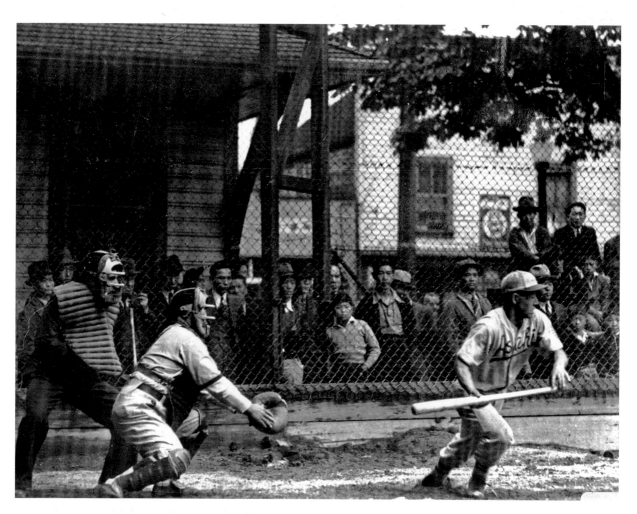

97 *Asahi player Mike Maruno at bat during a game at the Powell Street Grounds, 1920s, Nikkei National Museum # 2010.26.20*

100 *Peggy Middleton (Yvonne de Carlo) (centre) and Aussie the Boxing Kangaroo, June 12, 1939,* Vancouver Sun

YVONNE DE CARLO

Actress Yvonne de Carlo was born Margaret Yvonne ("Peggy") Middleton in Vancouver's St. Paul's Hospital and raised in the West End by a single mother determined that her daughter would have the show business life she always wanted for herself. Her nickname came from Baby Peggy, a child star in 1920s Hollywood, but Middleton later combined her middle name with her mother's maiden name to get the more exotic-sounding Yvonne De Carlo. Much of her childhood was spent taking acting and dance lessons at June Roper's school on Granville Street. De Carlo was a chorus girl at the Palomar and Cave supper clubs and in dance revues performed before the films were shown at the Orpheum Theatre. At the Beacon Theatre in 1939, she spent a week refereeing matches between Aussie the Boxing Kangaroo and his trainer. After the first match, seventeen-year-old De Carlo raised Aussie's paw in victory, as she had been instructed. She was taken aback when the animal started dancing around her and tousling her hair. De Carlo yelped, hoping someone would come to her rescue, but no one did—instead, the audience howled with delight. By the next night, she'd caught on that it was part of the choreography.

De Carlo moved to Hollywood soon after the Pantages show and landed a number of bit parts before her breakout role in *Salome Where She Danced* (1945). She appeared in dozens of films and TV shows, but today is best remembered for her roles in *The Ten Commandments* (1956) and as Lily on the 1960s sitcom *The Munsters*. When she returned to Vancouver as a big star, the Cave Supper Club hosted a gala dinner in her honour. Howard Hughes had become obsessed with her after seeing her in *Salome* and flew up from California in his private jet. Their meeting at the Cave was the beginning of a love affair that she describes in her 1987 autobiography, *Yvonne*.[101]

106 Guy Glover, quoted in Toby Gordon Ryan, *Stage Left: Canadian Theatre in the Thirties: A Memoir* (Toronto: CTR Publications, 1981), 63. Glover's "lost years" comment is probably a reference to Barry Broadfoot's popular oral history collection, *Ten Lost Years, 1929–1939: Memories of the Canadians Who Survived the Depression* (Toronto: Doubleday, 1973).

107 Paul Yee, *Saltwater City: An Illustrated History of the Chinese in Vancouver* (Vancouver: Douglas & McIntyre, 2006), 38.

108 Ibid.

109 Yun Ho Chang interview, in Marlatt and Itter, eds., *Opening Doors: In Vancouver's East End: Strathcona*, 62.

110 *Province*, October 20, 1914.

111 *Vancouver Sun*, November 10, 1914.

112 *BC Federationist*, November 20, 1914.

113 Irene Howard, *The Struggle for Social Justice in British Columbia: Helena Gutteridge, the Unknown Reformer* (Vancouver: UBC Press, 1992), 108–112.

114 *News-Advertiser*, May 9, 1911.

115 Charles Chaplin, *My Autobiography* (New York: Plume, 1992 [1964]), 128.

116 Jean Barman, *The West Beyond the West: A History of British Columbia*, 3rd ed. (Toronto: University of Toronto Press, 2007), 160.

117 *Vancouver Sun*, November 3, 1914.

118 Fred Taylor, interview in Liv Kennedy, Lorraine Harris, and Elva Oglanby, *Vancouver, Once Upon a Time: A Collection of Stories* (Vancouver: CJOR, 1974), 12.

119 Ibid., 9.

120 Ibid., 13; *Globe and Mail*, June 1, 2011.

121 *Vancouver Sun*, September 18, 1976.

122 *Globe and Mail*, June 1, 2011.

123 For more on the *Komagata Maru* incident, see Ali Kazemi, *Undesirables: White Canada and the Komagata Maru—An Illustrated History* (Vancouver: Douglas & McIntyre, 2012).

124 *Vancouver Sun*, September 18, 1976.

125 *Chicago Defender*, December 10, 1921.

126 Douglas L. Hamilton, *Sobering Dilemma: A History of Prohibition in British Columbia* (Vancouver: Ronsdale Press, 2004), 143.

127 Prohibition was repealed in 1921 following a 1920 plebiscite on the issue, but booze was heavily regulated through "government control," and it was still many years before the laws liberalized to allow for such things as cabarets being allowed to sell alcohol. Hotel bars such as the Patricia became beer parlours in 1925 when the law was changed to allow "beer by the glass." However, music, dancing, and pretty much anything else besides drinking were not allowed because lawmakers wanted to prevent a "saloon-like atmosphere and excessive camaraderie" from developing. Robert A. Campbell, "Managing the Marginal: Regulating and Negotiating Decency in Vancouver's Beer Parlours, 1925–1954," *Labour/Le Travail*, 44 (Fall 1999), 113. First Nations people were not allowed to buy alcohol until the 1950s, and until 1962 could only legally purchase and consume it in bars. See *Spokane Daily Chronicle*, July 2, 1962.

128 On the Reifel family, see Lazarus, *At Home with History*, 29–41.

129 *Province*, October 10, 1917.

130 *Province*, October 12, 1917.

131 *Vancouver Sun*, October 10, 1917.

132 Mark Miller, *The Miller Companion to Jazz in Canada and Canadians in Jazz* (Toronto: Mercury Press, 20013), 156.

133 *Chicago Defender*, November 2, 1918.

134 *Chicago Defender*, September 6, 1919.

135 Jelly Roll Morton, cited in Alan Lomax, *Mister Jelly Roll: The Fortunes of Jelly Roll Morton, New Orleans Creole and "Inventor of Jazz"* (Berkeley, CA: University of California Press, 1973), 170.

136 Jelly Roll Morton said he worked for Patty Sullivan at the Regent Hotel, but directories show Sullivan's club was at 768 Granville Street. For more on Sullivan, see Jim Coleman's column in the *Calgary Herald*, October 5, 1950.

137 Jelly Roll Morton, cited in Alan Lomax, *Mister Jelly Roll: The Fortunes of Jelly Roll Morton, New Orleans Creole and "Inventor of Jazz"* (Berkeley, CA: University of California Press, 1973), 171–72.

138 *Chicago Defender*, July 31, 1920.

139 *Chicago Defender*, January 8, 1921.

140 These stories are contained in *Bricktop* (New York: Welcome Rain Publishers, 2000 [1983]).

141 *Chicago Defender*, February 14, 1920.

142 *Bricktop*, 72.

143 Donald Davis, "Technological Momentum, Motor Buses, and the Persistence of Canada's Street Railways to 1940," *Material History Review* 36 (Fall 1992), 9.

144 *Financial Post*, June 23, 1917.

145 Lani Russwurm, "Constituting Authority: Policing Workers and the Consolidation of Police Power, 1918-1939" (MA thesis, Simon Fraser University, 2007), 69.

146 Lani Russwurm, "What Frankie Said: The Trial of Frankie Russell," *BC History* 40, no. 4 (2007): 18–22.

147 Nora Hendrix interview, in Marlatt and Itter, eds., *Opening Doors in Vancouver's East End*, 84.

148 Lani Russwurm, "Black and Blue, Life and Death," *Republic of East Vancouver*, nos. 181 and 182 (February 2008).

149 Ross Lambertson, "The Black, Brown, White, and Red Blues: The Beating of Clarence Clemons," *Canadian Historical Review* 85, no. 4 (December 2004): 755–76.

150 James S. Woodsworth, *Strangers Within Our Gates, or, Coming Canadians* (Toronto: The Missionary Society of the Methodist Church, 1909).

151 J.S. Woodsworth, *On the Waterfront* (Ottawa: The Mutual Press, n.d. [1918]), 6.

152 *New York Evening World*, May 28, 1919.

153 *Vancouver Sun*, November 1, 1918; *Province*, October 29, 1918.

154 For two examples of failed Human Flies, see *The Day Book*, January 8, 1914 and *Los Angeles Herald*, June 22, 1910.

155 Margaret W. Andrews, "Medical Services in Vancouver, 1886–1920: A Study in the Interplay of Attitudes, Medical Knowledge, and Administrative Structures," (PhD diss., University of British Columbia, 1979), 241.

156 *Vancouver Sun*, July 15, 1939.

157 *New York Times*, July 16, 1939.

158 *Vancouver Sun*, July 28, 1922.

159 *Vancouver Sun*, July 29, 1922.

160 Major James Skitt Matthews, *Early Vancouver*, vol. 3 (Vancouver: City of Vancouver, 2011), 68.

161 *Vancouver Sun*, June 16, 1921.

162 For a Full account of the race, see Shirley Jean Tucker, *The Amazing Foot Race of 1921* (Victoria: Heritage House Publishing, 2011).

163 Chris Hives, "The Great Trek: The Student Pilgrimage that came to Define a University," *Trek* (Spring 2001), 12–17.

164 *Vancouver Sun*, December 3, 1926.

165 Michael Allen, *Rodeo Cowboys in the North American Imagination* (Reno, NV: University of Nevada Press, 1998), 124.

166 Tom Bishop, "A. D. 'Cowboy' Kean," *Canadian Cowboy Country Magazine* [online], accessed March 29, 2013, http://www.cowboycountrymagazine. com/2010/11/ad-cowboy-kean/.

167 Some of the details of Quick's life are disputed, including his age. His death certificate states he was ninety-six when he died, not 111.

168 *Vancouver Sun*, October 17, 1931.

169 Quick's role in the first sewing machines is also questionable. The Vancouver Museum has his machine that dates to 1850 (Elias Howe patented the sewing machine in 1846) as well as a letter from city archivist Major J.S. Matthews discussing Quick's various claims. Letter from Major J.S. Matthews, May 27, 1939, Museum of Vancouver #H998.15.1.

170 *Vancouver Sun*, May 10, 1932.

171 Chuck Davis, *The Chuck Davis History of Metropolitan Vancouver* (Madeira Park, BC: Harbour Publishing, 2011), 178.

172 *Time Magazine*, December 14, 1936.

173 Bessie Lamb, "Origin and Development of Newspapers in Vancouver" (MA thesis, University of British Columbia, 1942), 81–85.

174 *Vancouver Courier*, July 25, 2008.

175 *Ottawa Citizen*, September 14, 1928.

176 *Maclean's Magazine*, October 1, 1950.

177 *Globe and Mail*, November 29, 2004.

178 "It's a Bald-headed Boy!" [blog], accessed February 21, 2013, http:// bald-headedboy.blogspot.ca/2010/05/bob-bouchette-was-writer-for-vancouver. html.

179 Pierre Berton, *The Great Depression, 1929-1939* (Toronto: McClelland & Stewart, 1990), 320–21.

180 *Life Magazine*, February 24, 1941, 107.

181 *Ottawa Citizen*, June 11, 1935. On the role of women during the 1935 unemployed protests, see Irene Howard, "The Mother's Council of Vancouver: Holding the Fort for the Unemployed, 1935–1938," *BC Studies* nos. 69–70 (Spring/Summer 1986), 249–87.

182 Toby Gordon Ryan, *Stage Left: Canadian Workers Theatre, 1929–1940* (Toronto: Simon & Pierre, 1985).

183 Michael Lonardo, "Under a Watchful Eye: A Case Study of Police Surveillance During the 1930s," *Labour/Le Travail*, 35 (Spring 1995): 11–41.

184 Mackenzie King, "The Diaries of William Lyon Mackenzie King," Library and Archives Canada, MG26–J13, April 22, 1936.

185 Arlene Chan, *The Chinese in Toronto from 1878: From Outside to Inside the Circle* (Toronto: Dundurn Press, 2011), 90.

186 Larry Wong, "Tommy Wong," *Chinese Canadian Military Museum Society* [online], accessed February 27, 2013, http://www.ccmms.ca/veteran-stories/air-force/tommy-wong/.

187 *Vancouver Sun*, July 8, 1939.

188 Jari Osborne, dir., *Sleeping Tigers: The Asahi Baseball Story,* online video (Vancouver: National Film Board, 2003), accessed June 19, 2013, http://www.nfb.ca/film/sleeping_tigers_the_asahi_baseball_story.

189 "Vancouver Asahi," *The Canadian Baseball Hall of Fame & Museum* [website], accessed June 19, 2013, http://baseballhalloffame.ca/museum/inductees/vancouver-asahi.

190 *Vancouver Courier*, September 16, 2011.

191 Yvonne De Carlo with Doug Warren, *Yvonne: An Autobiography* (New York: St Martin's Press, 1987).

CHAPTER THREE

Modern Times: 1940–1972

WORLD WAR II HAD AN enormous impact on the city of Vancouver. The anticipated and much-feared attack by Japan never happened, but the city nevertheless prepared for it with military installations in Stanley Park and Point Grey, blackouts, air-raid precaution drills and educational programs, and the internment and expulsion of people of Japanese origins from the coast, regardless of whether they were born in Tokyo or at Vancouver General Hospital. During the 1940s, women joined the workforce in greater numbers than ever before as men were shipped off overseas to fight. Hundreds of soldiers and sailors were housed downtown in the Hotel Vancouver and the Dunsmuir Hotel, waiting for their turn to be sent to war.

The war also abruptly ended the Great Depression. Wartime industries and military service absorbed the unemployed almost immediately. Shipbuilding and airplane manufacturing at the Boeing plant were two

98 *Casa Loma Café, 1940s, Jack Lindsay, CVA #1184-3261*

of Vancouver's main contributions to the machinery of war.

When World War II ended, veterans returned to find a severe housing shortage, the result of years of hardship and economic depression that had stifled development. The city's first social housing projects began to appear in the 1950s, and "urban renewal" schemes were hatched by city planners caught up in the wave of post-war modernism that sought to reconfigure the city around private automobile use and suburbanization. Developers transformed the West End from a neighbourhood of large houses to a dense sea of apartment buildings, and the commercial retail strip on East Hastings Street suffered after streetcars and interurban train tracks were pulled up to encourage shopping in suburban malls instead of downtown. Determined to lead the way, Woodward's Department Store built a huge parking garage on Cordova Street and aggressively expanded to suburban shopping malls, beginning in 1950 with Park Royal Mall in West Vancouver, one of Canada's first. In so doing, Woodward's fuelled the very process that eventually led to the store's demise in 1993 and the economic decline of the East End.

With the popularity of swing jazz in the late 1930s and 1940s, Vancouver's first clearly defined youth subculture emerged. Young people wearing baggy zoot suits were automatically deemed to be rebels. They organized themselves into "gangs"—groups of neighbourhood friends who hung out in cafés, frequented teen dance clubs, and occasionally skirmished with gangs from other parts of town. Styles

changed as rock and roll superseded jazz as the music of choice for teenagers in the late 1950s, but youth gangs and the related panics over illicit drug use and juvenile delinquency remained preoccupations of the authorities and Vancouver's chattering class for years to come.

As the beatnik culture drifted up the coast from San Francisco in the 1950s, another youth subculture took shape around jazz music, art, and poetry. The Cellar jazz club at Main and Broadway was the original hub for this scene, but soon other jazzy coffee houses opened up closer to the University of British Columbia. By the late 1960s, Kitsilano had evolved into the epicentre of a large hippie culture, elements of which have survived to this day. The Commercial Drive area was home to the more politically active elements of the counterculture, and Gastown, with its head shops and leather shops, was a hippie haven before it became a tourist hotspot and heritage area in the 1970s.

The 1960s counterculture in Vancouver was made up of both local baby boomers as well as a flood of more-or-less politicized young Americans who were dodging the draft in the United States

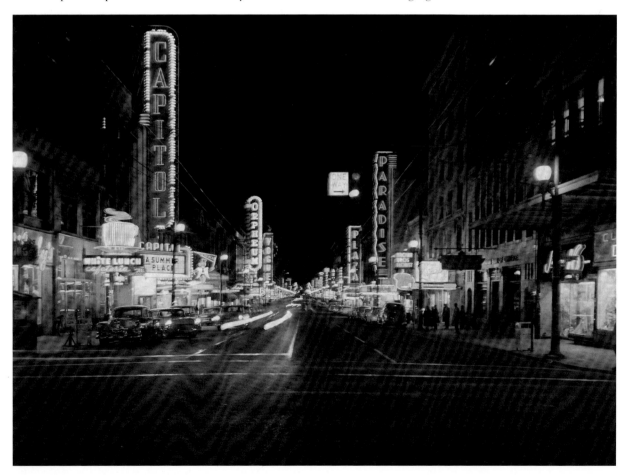

99 *Theatre row, 1959, B.C. Jennings, CVA #672-1*

and/or partaking in Vancouver's blossoming hippie scene. Tensions between the youth and the "establishment" came to a head under the civic administration of Mayor Tom "Terrific" Campbell. A developer who had made a fortune building West End apartments, as mayor, Campbell positioned himself squarely against the hippies and particularly against the counterculture newsweekly, the *Georgia Straight*. Campbell's crusade climaxed with the 1971 Gastown Riot, which broke out during a "smoke-in" organized to protest constant police harassment of young people who liked to partake in cannabis consumption.

Vancouver's nightlife changed dramatically in the post-war era as liquor laws were liberalized. Ballrooms and supper clubs such as the Palomar and the Cave were allowed to legally serve alcohol to patrons of their burlesque and popular music acts. Outside the clubs, Vancouver was awash in the dancing neon signs that had proliferated on the city's downtown streets since the first one went up in the 1920s.

The horrific experiences of World War II and the global wave of decolonization helped to trigger what became the Civil Rights Movement, which gradually eliminated or at least reduced many of Canada's overtly racist policies. Milestones included the repeal of the Chinese Exclusion (Immigration) Act, which had banned the immigration of Chinese people since the 1920s, and the extension of the franchise to Asians. The offence of "selling liquor to an Indian" was struck from the books in the 1950s, and in 1960, Native people were allowed to vote without giving up their status and rights under the Indian Act. Protests started to become more commonplace in the 1960s, at first over issues such as nuclear disarmament and discrimination and later in the decade over police brutality, US foreign policy, housing issues, the environment, or urban development.

The ambitious development schemes aimed at modernizing the city were often met by protests so that some projects were only partially completed if not abandoned altogether. People in affected neighbourhoods were galvanized into action, including the Chinese residents who led the campaign to stop the freeway that would have obliterated much of Chinatown, Strathcona, and Gastown. The success of the anti-freeway fight in the early 1970s marked a sea change in Vancouver's civic culture that is still felt today as totalizing, modernist schemes have given way to development processes that allow for more citizen participation and, at least ostensibly, a more holistic approach to city planning.

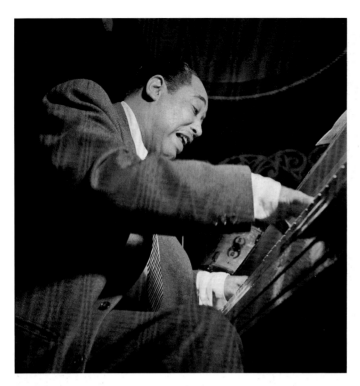

101 *Duke Ellington, 1940s, William P. Gottlieb, LoC #LC-GLB23-0251*

SWING JAZZ

Vancouver may have enjoyed a small but flour-
ishing jazz scene during the prohibition era, but
it wasn't until 1940 that the big names started
coming to town. An eleven-year boycott of
American acts by the local musicians' union ended
in 1940, and Duke Ellington made his Vancouver
debut on April 15 of that year.[192] The show was
billed as "The Biggest Dance in Vancouver's
History!" Four thousand people flocked to the
Forum, paid their $1.10 at the door, and danced
on the 25,000-square-foot (2,323 sq. metre)
dance floor until one in the morning.[193]

 Among the young jitterbugs showing off
their moves was Jimi Hendrix's father Al, who
appeared in the *Vancouver Sun* the next day with
his back to the camera. The paper's coverage
focused mostly on the "hep cat" dancers and
an unimpressed ninety-year-old former dance
instructor.[194] *DownBeat Magazine* reported that
it had been a great show, "although—as usual—
about sixty per-cent of the band's most impressive
work sailed over all but a few heads,"[195] and
lucrative for Ellington, too. Band leader Benny
Goodman played to an even bigger crowd at the
Forum a couple of months later, and thereafter
Vancouver was a regular tour stop for all the big-
name acts.

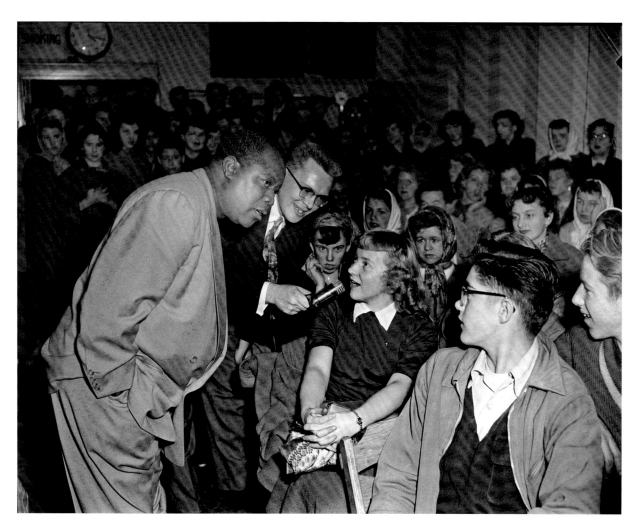

102 *Louis Armstrong on CJOR's "Theme for Teens," 1954, VPL #82431*

WORLD WAR II

Although Vancouver was far from any theatre of conflict, World War II affected everyday lives in a variety of ways, including rationing of consumer goods, nighttime blackouts, schoolchildren wearing gas masks, the militarization of areas in Stanley Park and Point Grey, and women working in factories to produce the instruments of war.

For young Warren Bernard, the war gave him more than his fifteen minutes of fame after *Province* photographer Claude P. Dettloff snapped a photo of him reaching toward his soldier father in New Westminster in 1940. The iconic image, named "Wait for Me, Daddy" by *Life Magazine*, became the most reproduced wartime photo to come out of Canada. Every Vancouver school had it hanging on its walls, and Bernard was enlisted to appear at war-bond drive events.[196]

103 *Warren Bernard at a war-bond drive next to the "Wait for Me, Daddy" photograph, 1944, Don Coltman, CVA #586-2605*

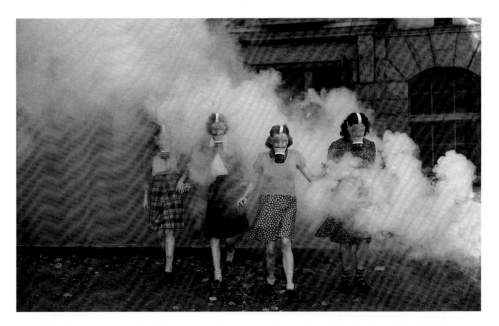

104 *Girls during a gas-mask drill using simulated gas at Queen Mary School, 1941, VPL #30424*

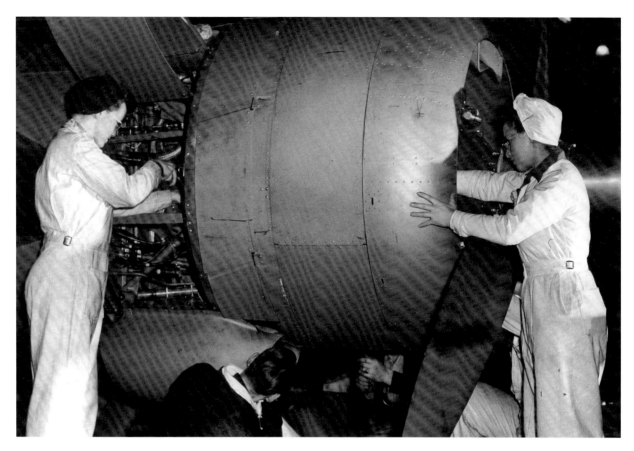

105 *Women working at the Sea Island Boeing plant, Briddick, 1945, CVA #Air P1.3*

106 *Military training exercise at Kits Beach, ca. 1942, Jack Lindsay, CVA #1184-3496*

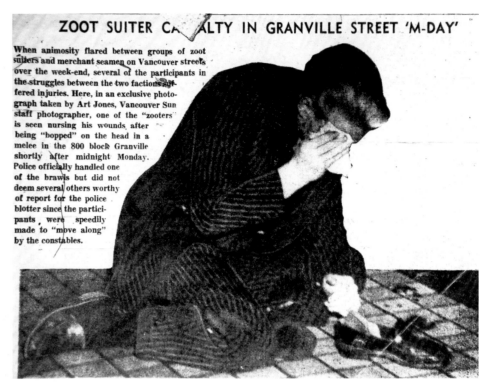

ZOOT SUITER CASUALTY IN GRANVILLE STREET 'M-DAY'

When animosity flared between groups of zoot suiters and merchant seamen on Vancouver streets over the week-end, several of the participants in the struggles between the two factions suffered injuries. Here, in an exclusive photograph taken by Art Jones, Vancouver Sun staff photographer, one of the "zooters" is seen nursing his wounds after being "bopped" on the head in a melee in the 800 block Granville shortly after midnight Monday. Police officially handled one of the brawls but did not deem several others worthy of report for the police blotter since the participants were speedily made to "move along" by the constables.

107 *An injured zoot suiter, July 31, 1944,* Vancouver Sun

ZOOT SUITERS

Swing jazz culture first arrived in Vancouver through the railroad porters living in the black community near the train station in the city's East End. On Saturday afternoons, the Parks Board would set up a sound system in MacLean Park in Strathcona. Neighbourhood kids brought their swing records, and the black kids taught the others how to jitterbug. Eventually teen dancehalls sprang up, including Happyland at the Pacific National Exhibition.[197] With the popularity of swing jazz came a new youth subculture in the early 1940s—the zoot suiters. They were generally reviled in part because their exaggeratedly baggy clothes didn't conform with wartime restrictions and in part because it was felt that young people should be fighting for their country instead of jitterbugging and hanging out in cafés.

In the dog days of summer in 1944, tensions between one group of zoot suiters known as the Home Apple Pie Gang (after the café they frequented at Hastings and Princess Streets) and some sailors stationed downtown while waiting to be shipped to war came to a head.[198] The sailors looked down on the zoot suiters, assuming they had shirked the call of duty. The Home Apple Pie Gang, meanwhile, considered the cocky sailors "farm boys" intruding on their turf. One night, a drunken sailor fell down the stairs of a Granville Street nightclub, but reported to the police that he had been beaten up by zoot suiters. The truth eventually came out, but not before the incident triggered more than a week of skirmishes between the two groups resulting in some serious injuries and jail time for several zoot suiters.[199]

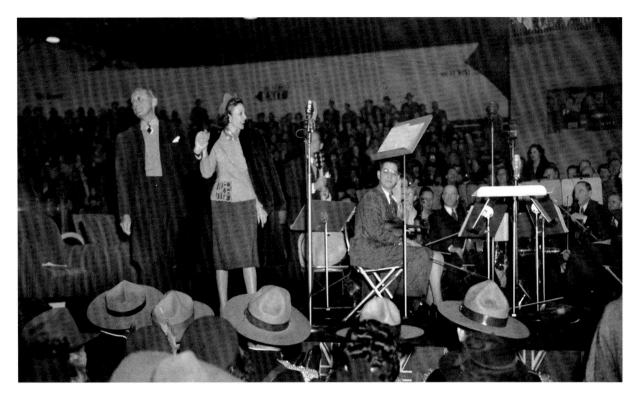

108 *Jack Benny and Mary Livingstone broadcasting their radio show from the Vancouver Forum, 1944, CVA #1184-525*

JACK BENNY & MARY LIVINGSTONE

Jack Benny performed with the Marx Brothers in a week-long vaudeville engagement at Vancouver's Orpheum Theatre in the spring of 1922. One night, Zeppo Marx invited him to a dinner at the home of his Vancouver friend David Marks. Soon after Marks's fourteen-year-old daughter Sadie began to play her violin, Benny cringed and loudly whispered to Zeppo, "Let's get outta here!" (Ironically, Benny's own dreadful violin playing would later become a signature part of his comedy routine.)[200]

Sadie Marks met Benny in California a few years later, and the two married in 1927. Eventually she joined Benny's act using the name Mary Livingstone. The couple returned to Vancouver many times and in April 1944, brought the cast and crew from their popular radio show up from New York to broadcast from the Forum as part of a war-bond drive.

The age difference between Benny and Livingstone was a staple in their routine, including this gem from the Vancouver show:

Jack: You know, Mary, being in Vancouver brings back memories to me, too. When I was in vaudeville, I played the Orpheum Theatre many a time. Did you know that?

Mary: Did I know that? Jack, every time you played here didn't you notice a little girl in the third row in the aisle seat, with long blonde pigtails and a pink ribbon in her hair?

Jack: Well, I'll be darned! Was that you?

Mary: No, that was my mother.

Jack: Now cut that out![201]

STREET PHOTOGRAPHY

Street photographers took photos of pedestrians, who were then given a receipt to take to the photographer's studio where they could buy their photos. The practice was especially popular during the war because camera film was difficult to acquire, making street photographers one of the few ways to get snapshots of family and friends. These photographers were fixtures on busy commercial streets like Granville and Hastings, but were also in-demand in Stanley Park where they generated thousands of photos of visitors to attractions like the Hollow Tree (p. 52).

Vancouver's best-known and last street photographer (but by no means the only one) was Foncie Pulice, who began taking pictures in 1934 as a way to meet girls and continued right up until his retirement in 1979. Occasionally people would phone Pulice to let him know what time they would be passing his corner. At the peak of his business, he had operations at the Pacific National Exhibition, Stanley Park, and on Granville Street that together captured 4,000 images a day. It's estimated that Pulice took a million photographs over his forty-five-year-long career.[202]

109 *Street photographer Audrey Gibson handing a receipt to a customer, 1942, Jack Lindsay, CVA #1184-250*

110 *Chocolate bar protest in Ladysmith, BC, April 26, 1947,*
Vancouver Sun

CHOCOLATE BAR PROTEST

In April 1947, the price of a chocolate bar in
Canada skyrocketed from a nickel to eight cents,
apparently caused by a sharp increase in the price
of cocoa beans. Kids in the town of Ladysmith
(pictured) on Vancouver Island were the first
to raise a stink by picketing their local candy
store, and soon the campaign became national.
Children in Fredericton, New Brunswick, pooled
their resources and made homemade fudge to
get them through the crisis. In Victoria, they
stormed the legislature and shut down the provin-
cial government, and near Vancouver, a bicycle
parade blocked traffic on Kingsway for two hours.
Retailers complained that sales of candy bars
plummeted by eighty percent almost overnight.[203]

Just when the protest was at its height and vic-
tory seemed within reach, the thrill-kill *Toronto
Telegram* published an editorial claiming that
this campaign was just another Communist
conspiracy and that these kids were dupes of
Moscow. "Communist youth organizers," alleged
the *Telegram*, "have been instructed to use every
possible means of developing and encouraging
the chocolate bar agitation."[204] At the height of
the Cold War, support for the chocolate protes-
tors withered almost instantly. In Vancouver, the
2,500-member Sat-Teen Club withdrew its sup-
port under pressure from city officials, police, and
the clergy, stating that "mob demonstrations and
strikes are not consistent with the ideals of the
club."[205] Norman Penner, head of the National
Federation of Labour Youth, which coordinated
the national campaign, was indeed the son of a
founding member of the Communist Party of
Canada and went on to become a prominent
Marxist historian. Nevertheless, it's doubtful
anyone in Moscow even knew about the strike.

III *Siwash Rock and possibly Douk Beach, 1940, Don Coltman, CVA #586-460*

DOUK BEACH

For all of its known history, Stanley Park has been a home for some people, despite the best efforts of officials over the years to make it a strictly resident-free park. Two of the park's stealthier denizens were discovered and evicted by the Vancouver police in 1947. The first was John Hood, a hoarder who left debris near his abode that alerted the authorities to his presence in the area. It took two years, but Vancouver's finest finally tracked him down and found he had been living in a hollow Douglas fir near Siwash Rock for a couple of years. To evade police, Hood did not stay in one place for too long, although he kept his belongings—mostly items park visitors had lost or discarded—in his tree house, which he camouflaged with branches. When police finally found him, he was making tea in a nearby cave.[206]

Through their interrogation of John Hood, police learned that the cave had been home to another man named Wilfred "Frenchy" Chicoine for seventeen years, less the four years he spent overseas fighting in World War II. Frenchy was hauled before a judge and given the choice to find a new home outside of the park or spend a year in prison.[207]

John Hood also told police that the view from the cave included nude sunbathers. Locals had dubbed the beach "Douk Beach" after the Sons of Freedom Doukhobor sect known for disrobing as an act of protest.[208] Its origins as a nude sunbathing spot went back to the 1930s when unemployed men, unable to afford beach attire, cleared away rocks and debris so they could use the beach for skinny dipping and nude sunbathing.

In 1947, an unnamed "concerned citizen" who had camped out in the woods for three days observed the activity at Douk Beach and reported his findings to the park police. *Vancouver Sun* columnist Jack Scott called him the "Moron of the Week … with his beady eyes eager to discover evil." But park police weren't interested in the case since "there has been nude bathing within the vicinity of this famous [Siwash] rock since beyond the memory of the white man."[209]

HOTEL VANCOUVER OCCUPATION

Veterans returning from World War II found Vancouver in the midst of a housing crisis. Years of underdevelopment during the war and economic depression before it combined with a booming population to create a serious housing shortage for the ex-servicemen coming back into the city. To address the problem, veterans occupied the old Hotel Vancouver, which was empty and soon to be demolished after serving as a barracks during the war. (The current Hotel Vancouver was completed in 1939.)

The ex-servicemen had public sympathy on their side, so instead of moving to evict them, the government gave them money to run the hotel as a temporary hostel. For two years, over one thousand people lived at the old Hotel Vancouver. Rules and guidelines were established to ensure their new home was well maintained and liveable. In 1948, Eaton's department store bought the building and demolished it. By then, the remaining homeless vets had moved into the old Dunsmuir Hotel, which was serving as a men's hostel run by the Salvation Army.[210]

112 *Occupation of the second Hotel Vancouver, 1946, VPL #42379*

113 *Malcolm Lowry holding a bottle of gin and a paperback at his squatter's shack in Dollarton, 1953, UBC #BC 1614-107*

MALCOLM LOWRY

Malcolm Lowry was an English writer best known for his masterpiece novel *Under the Volcano* (1947). He'd finished the first draft in 1937, but it took three more versions before it was accepted for publication. Lowry moved to Vancouver in 1939, and after getting rejected by the army, rented an old squatter's shack on a beach in Dollarton, where Cates Park is today in North Vancouver. He was later joined by an actress he'd met in Hollywood, Margerie Bonner, who helped him to edit *Under the Volcano* while she was here. Bonner and Lowry got married and lived at Dollarton until 1954.

Malcolm Lowry revised *Under the Volcano* several times during his time in Dollarton and nearly lost the manuscript when his shack burned to the ground in 1944. After the fire, the Lowrys went to Ontario, where Malcolm finished the final draft on Christmas Eve, 1944. The couple returned to Dollarton and rebuilt the shack. *Under the Volcano* was finally accepted for publication in 1946. The book is set in Mexico, but the protagonist owns an island in British Columbia, which he describes as a "genteel Siberia, that was neither genteel nor a Siberia, but an undiscovered, perhaps an undiscoverable Paradise."

Lowry loved living on Burrard Inlet and loved BC, but he wasn't crazy about Vancouver, which he called Enochvilleport, meaning "city of the son of Cain." In his novel, Gastown became "Gaspool," presumably to make it sound more like "cesspool."[211] Lowry had been an alcoholic since his teens, and among his criticisms of Vancouver were its beer parlours and BC's archaic liquor laws, which segregated single men from "ladies and escorts" and forbade music. "Nowhere in the world perhaps were there similar places whose raison d'être is presumably social pleasure where this is made harder to obtain," he wrote in *October Ferry to Gabriola* (published

posthumously in 1970), "nowhere else places of such gigantic size, horror and total viewlessness."

After hearing that a famous stand of giant trees in Stanley Park known as the Seven Sisters were dying because their root systems had been damaged by the continuous human traffic, Lowry penned a letter to a local newspaper that became part of his short story, "The Bravest Boat." He hinted that the trees were committing suicide "rather than live any longer near civilisation." Lowry proposed preserving the trees by encasing them in plastic and installing a plaque—also in plastic—"commemorating their high-minded murderer: Persecuted & killed by civilisation in the form of the Noble City of Vancouver. Nee Gastown R.I.P. (Hugged to death out of love)."[212]

Vancouver and British Columbia made frequent appearances in Lowry's later work, most of which was edited by his wife and published after his death, but none received near the acclaim given *Under the Volcano*, which the Modern Library ranked as the eleventh-best novel of the twentieth century. Lowry died in 1957 from "misadventure" and wrote his own epitaph:

> Malcolm Lowry
>
> Late of the Bowery
>
> His prose was flowery
>
> And often glowery
>
> He lived nightly, and drank daily
>
> And died playing the ukulele.[213]

YOUSUF KARSH

Yousuf Karsh is arguably the most famous photographer to come out of Canada, known for his many iconic portraits of public figures from Winston Churchill to Audrey Hepburn. In 1952, *Maclean's* magazine hired Karsh for a series profiling Canadian cities. Editor and future historian of Canada Pierre Berton briefed Karsh on the city, pointing out features such as the gaudy neon-lit streets downtown, Stanley Park, the waterfront, and lumber baron H.R. MacMillan lording over his commercial empire from high up in the Marine Building in downtown Vancouver.[214]

The magazine wanted the series to highlight the underlying foundations of Canada's booming postwar economy, and for Vancouver it gave Karsh the theme of timber.[25] Ballerinas are a typical motif in Karsh's photography, and in the image on the following page he juxtaposes them against the Hollow Tree in Stanley Park to emphasize the relationship between culture and nature that is so pronounced in Vancouver. The nature/culture theme might appear to be Karsh deviating from the timber theme given to him, but both support the more general, clichéd notion that Canada's identity is determined by its geography.[216]

Karsh claimed in one of the captions that "every city has a slum, but I could not find any in Vancouver."[217] His choice to photograph the houseboat squatter colony that still lined Vancouver's shores in the 1950s, however, suggests that this sentiment came from the editors even though the caption attributes it to Karsh, since surely he would have noticed that some of Vancouver's poorest residents were houseboat squatters. To capture neon-lined Granville Street from above, Karsh borrowed a hydraulic lift from the BC Electric Railway Company. [218]

115 *Granville Street at night, 1952, Yousuf Karsh, LAC #PA-165855*

114 *Three ballerinas at Stanley Park's Hollow Tree, 1952, Yousuf Karsh, LAC #PA-207420*

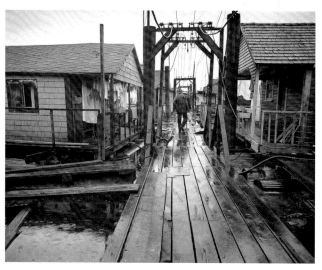

116 *Houseboat colony, 1952, Yousuf Karsh, LAC #PA-212776*

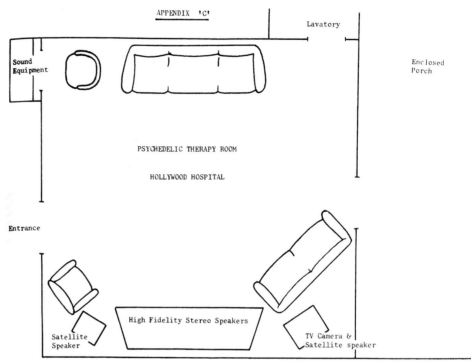

APPENDIX 'C'

Lavatory

Sound
Equipment

Enclosed
Porch

PSYCHEDELIC THERAPY ROOM

HOLLYWOOD HOSPITAL

Entrance

High Fidelity Stereo Speakers

Satellite
Speaker

TV Camera &
Satellite speaker

117 *The LSD room at Hollywood Hospital, from J. Ross MacLean, et al,* LSD-25 and Mescaline as Therapeutic Adjuvants: Experience from a Seven Year Study *(New Westminster, BC: J. Ross MacLean, 1965)*

LSD

One of the more fascinating chapters in Vancouver's long history with mind-altering substances comes from the early days of lysergic acid diethylamide (LSD) research in the 1950s. An unexpected but enthusiastic advocate of LSD experimentation was Al Hubbard, an eccentric and enigmatic American millionaire who became the biggest North American supplier of LSD through his Uranium Corporation, whose mailing address was 500 Alexander Street in Vancouver, a skid road rooming house.[219]

Hubbard turned thousands of people on to LSD, including writer Aldous Huxley, the head of Vancouver's Holy Rosary Cathedral, and various researchers and clinicians, including Dr J. Ross MacLean, who teamed up with Hubbard to lead an LSD program at Hollywood Hospital, a private facility in New Westminster that treated alcoholism and psychological disorders. Celebrities, cabinet ministers, and others who could afford the program fees were given LSD in an environment controlled and supervised by trained hospital staff who had themselves tried the drug. Staff members included B-movie starlet Mimsy Farmer and futurologist Frank "Dr. Tomorrow" Ogden. While tripping on acid, patients listened to classical music in a room adorned with a reproduction of Dali's *Crucifixion (Corpus Hypercubus).*[220]

The popularization of LSD as a recreational drug for hippies led to a moral panic, and the drug was banned. Hollywood Hospital survived until 1975; as for Hubbard himself, his mission as the "Johnny Appleseed of LSD" ate up his fortune, and he returned to the US.

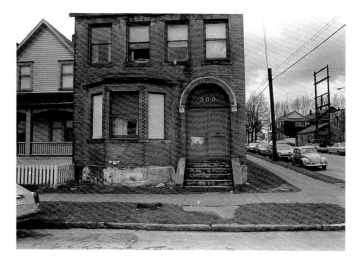

118 *Originally a brothel, then a home for sailors, 500 Alexander Street was a skid road rooming house when it served as the mailing address for the Uranium Corporation of British Columbia, 1972, Curt Lang, VPL #85872CC*

HUNTER S. THOMPSON

Hunter S. Thompson was a young and still unknown journalist in New York in 1958 when he saw a *Time Magazine* article describing the fresh direction Jack Scott, the new editor of the *Vancouver Sun*, was taking the paper.[221] Thompson had not yet seen an issue of the new-and-improved *Sun*, but thought it sounded like a paper for which he might like to work. He wrote to Scott, offering his services and asking to see a copy: "I stepped into a dung-hole the last time I took a job with a paper I didn't know anything about," Thompson wrote, but "unless it looks totally worthless, I'll let my offer stand."

Thompson apparently assumed Scott shared his low opinion of the state of journalism, for which Thompson had developed "a healthy contempt." He wrote, "As far as I'm concerned, it's a damned shame that a field as potentially dynamic and vital as journalism should be overrun with dull-ards, bums, and hacks, hagridden with myopia, apathy, and complacence, and generally stuck in a bog of stagnant mediocrity. If this is what you're trying to get the *Sun* away from, then I think I'd like to work for you."

Thompson had mainly worked as a sports writer, but could "write everything from warmon-gering propaganda to learned book reviews." He did not get the job at the *Sun* and later insisted his letter was "written in a frenzy of drink."[222]

119 *Hunter S. Thompson, WikiMedia Commons*

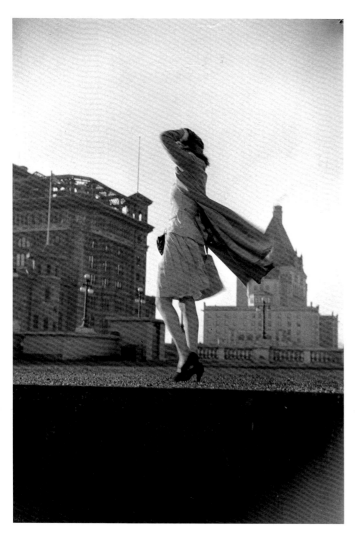

120 *Marie Moreau, 1942, Jack Lindsay, CVA # 1184-114*

MARIE MOREAU

Marie Moreau was the fashion editor at the *Vancouver Sun* when columnist Jack Scott began a brief stint as the paper's editor in 1958 and decided to mix things up a bit. Scott sent a sports writer and former BC Lions coach to report on tensions between China and Formosa (Taiwan) and sent Moreau to the Caribbean to cover the Cuban Revolution.[223]

The fashion editor managed to meet (and charm) Fidel Castro, who invited her "to go back to his revolutionary headquarters with him." He was better-looking in person, she wrote, but lest any female readers got the wrong impression, Moreau noted that Castro's "beard is straggly and unkempt. He wears a sweaty shirt that looks as though he hadn't changed it since the revolution began, and his fingernails are grimy."[224] Presumably Moreau didn't get to meet Che Guevara.

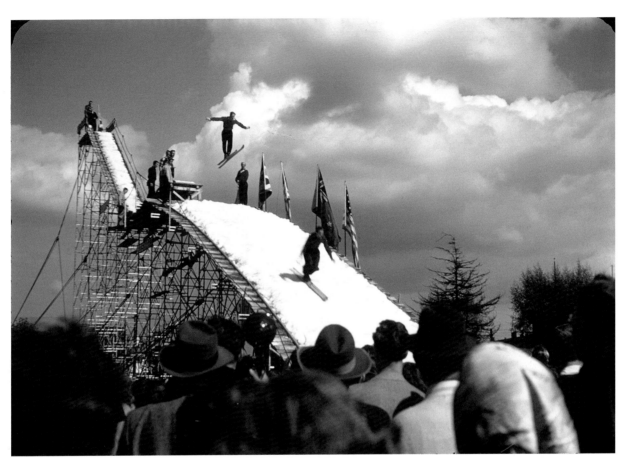

121 *Ski jump at Empire Stadium, Leslie F. Sheraton, 1958, CVA #2008-022.003*

SKI JUMP AT EMPIRE STADIUM

Vancouver hosted the Vancouver Centennial Ski
Jumping Tournament in May 1958 at Empire
Stadium. Ski jumpers from all over the world
took park in the three-day event, which attracted
25,000 spectators. The event was a success by all
measures except financial, thanks to the high cost
of building the jump and keeping it covered in
snow in balmy spring Vancouver weather.[225]

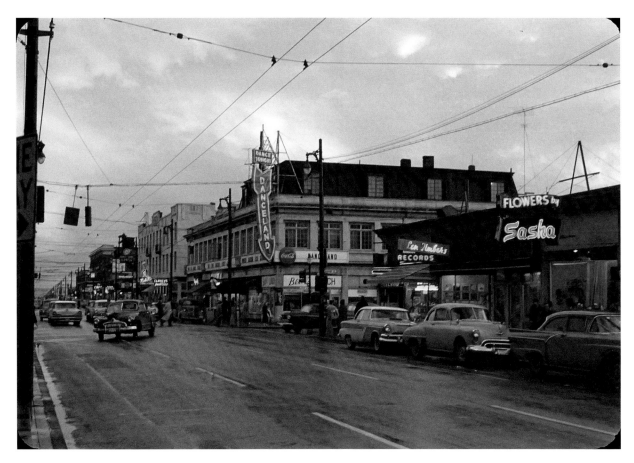

122 *Alexandra Ballroom/Danceland, late 1950s, Leslie F. Sheraton, CVA #2008-022.041*

DANCELAND

The Alexandra Ballroom was located on the second floor of the Clement Block on the southeast corner of Robson and Hornby Streets. The building was erected in 1922 and was, like the Commodore, one of the more upscale ballrooms in town. Also, like the Commodore, it had a springy dance floor, built upon bags of horse hair. Bandleader Dal Richards first played the "Alex" in the 1920s as part of the Kitsilano Boys Band. It became known as Danceland in 1957, and besides featuring local talent, attracted a lot of the big names of the day, including Del Shannon, Ike and Tina Turner, Roy Orbison, Jerry Lee Lewis, and Bobby Darin. Radio station CKNW had its studios on the third floor. Unfortunately, the building was purchased by the provincial Social Credit government for a proposed civic centre that never got off the ground, and was demolished in 1965.[226]

ANDY WOLANDI

After Pacific National Exhibition clown Andy Wolandi boasted he could climb any building in Vancouver, someone suggested the Georgian Towers at 1455 West Georgia Street. The building's assistant manager warned hotel guests not to be alarmed if they saw a "human fly" outside their windows, though most did not heed her. Unaided by any climbing gear, Wolandi took twenty minutes to reach the top of the twenty-one storey hotel, from which he said the view was "terrific."[227]

123 *Andy Wolandi climbing Georgian Towers, 1962, VPL #40049*

LORETTA LYNN

Country superstar Loretta Lynn was first discovered in Vancouver. While living in Washington state, Lynn trekked up to Vancouver to sing at an informal jam space in Fraserview that was once home to a chicken coop. Executives from Zero Records, a local record company with financial backing from future mayor Art Phillips, saw Lynn perform and in 1960 signed her up to record *I'm a Honky Tonk Girl*, her first hit single.[228]

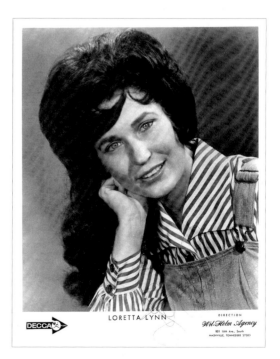

124 *Loretta Lynn publicity photo for Decca Records, courtesy of Jim Loessberg collection*

VANCOUVER BEATNIKS

The Beat Generation kicked off with a "Howl" at
the San Francisco poetry reading where Allen
Ginsberg first read his famous poem in 1955.
Within a few years, beatniks began appearing in
Vancouver sporting the tell-tale markings of goa-
tees and bare feet. Their preoccupations included
poetry, jazz, civil rights, and nuclear disarma-
ment. Their natural habitat was in coffee houses
sprouting up on the city's west side, close to the
university—with names like the Black Spot and
the Number Nine.

Beatniks were more middle-class and self-con-
sciously countercultural than the zoot suiters of
the 1940s and early 1950s, but they were simi-
larly young and considered ne'er-do-wells by the
more conservative older generation or "squares."
In a letter to the editor of the *Vancouver Sun*, for
example, one Patricia Young described beatniks
as "social and artistic failures who seek escape
from society and themselves through various
forms of exhibitionism and childish revolt against
all forms of common convention and common
sense."[229]

A group of senior girls at Lord Byng High
School made the news when they came to class
"wearing traditional Beatnik garb—black leotards,
black sweaters, black skirts or black slacks, and
white lipstick." At first the boys refused to talk
to them, but eventually came around. The Byng
rebellion was short-lived; the girls came to school
the next day wearing "conventional clothes" at
the request of the principal.[230]

The highlight of Vancouver's beatnik era
was a three-week poetry conference held at the
University of British Columbia, generally consid-
ered a landmark literary event because it brought
together an esteemed group of New American
Poets including Robert Creeley, Charles Olson,
Margaret Avison, and Allen Ginsberg. Among
the local participants who went on to make their

125 *A man being ejected by police from the Skillet Café on Granville
Street after a sit-in protesting discrimination against beatniks.
November 27, 1964; Ralph Bower,* Vancouver Sun

mark in Canadian literature were former and
current poet laureates of Canada George Bowering
and Fred Wah.[231]

By the spring of 1967, with the Summer of
Love just around the corner, Vancouver's small
beatnik scene was subsumed by the larger hippie
movement. West 4th Avenue was "Haight-
Ashbury North," and the "cynical Beats" were
now just "remnants of the Kerouac generation,"
according to a *Vancouver Sun* article explaining
the hippie phenomenon to its readers.[232]

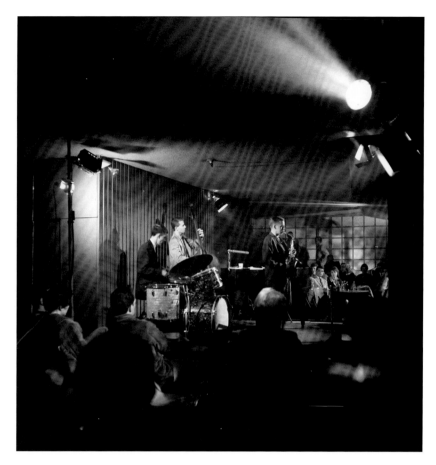

126 *The Cellar, Franz Lindner, 1961, CBC Archives*

THE CELLAR

The Cellar was a jazz club that opened in 1956 in the basement of 222 East Broadway. It began as a cooperative space for a group of be-bop players including Dave Quarin and Al Neil, who wanted a place to play and hone their chops. The Cellar was a bottle club, meaning it had no liquor licence, so customers brought their own booze. By its second week, people were lining up to get in.[233]

The Cellar quickly became the hottest jazz venue in town and one of the hottest on the West Coast. In addition to the local talent, big-name jazz musicians made it a routine stop on tours up the coast, including the Jazz Messiahs, Paul Bley, Art Pepper, Ornette Coleman, Charles Mingus, Stan Getz, Oscar Peterson, and Wes Montgomery. The club's popularity really soared once beat culture arrived in Vancouver in the summer of 1958 and turned young bohemians and college students on to jazz. The Cellar closed in 1964, but by then had paved the way for other jazz clubs such as the Black Spot, the Blue Horn, and the Inquisition Coffee House.[234]

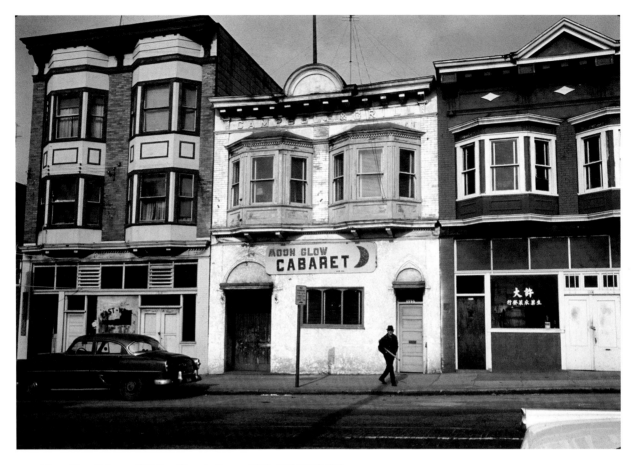

127 *Moon Glow Cabaret, 331 East Georgia Street, 1966, CVA #780-335*

THE MOON GLOW

The Moon Glow was already closed for a few years when this photo was taken, but in the late 1950s and early 1960s, it was a rhythm-and-blues club. Tommy Chong wrote about playing there with his band, the Shades:

The Moon Glow was owned by Daddy Clark, a railway porter who loved The Shades and wanted to see us back together. Railway porters played a big part in our development as blues musicians because they were the ones who brought records up from the States, turning us on to Hank Ballard and the Midnighters, who did tunes like "Sexy Ways," "Annie Had a Baby," and "The Twist." They brought us the latest records from Bo Diddley, Muddy Waters, and a host of other blues artists who were otherwise unobtainable. We would learn these great tunes and then play them for a grateful audience, who would be hearing them for the first time, since they were never played on the radio.[235]

Tommy Chong became well-known in the local music scene and had a brush with fame after the Supremes stopped by the Elegant Parlour, his underground club on Davie Street, and heard his band, Bobby Taylor and the Vancouvers. As a result, the Vancouvers signed with Motown Records, had some minor hits, and discovered the Jackson Five (Chong helped them sign to Motown too). After the Vancouvers fizzled, he turned his brother's topless bar at Main and Pender, the Shanghai Junk, into a comedy club where he teamed up with Cheech Marin to form the renowned comedy team Cheech and Chong.

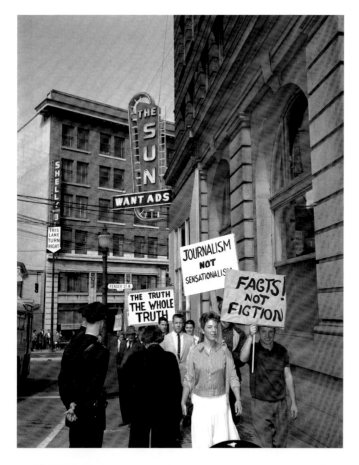

128 *Students protest "Sex Beach" article, May 22, 1960, Robert E. Olsen, VPL #41908*

STUDENT PROTEST

Students from Magee Secondary School picketed the *Vancouver Sun* to protest its coverage of a teen beach party a few days earlier at Spanish Banks. The paper characterized the shindig as a "high school liquor and sex party" and a "drunken sex orgy," even though no liquor was present and no sex took place.

The *Sun* didn't bother explaining itself in its coverage of the protest, but a letter writer in the same issue opined that there were "too many 'adults' who love to say 'I don't know what our younger generation is coming to' after reading a lot of rot like your article."[236]

THE BIG PAINT-IN

When the BC government decided to install a fountain at the provincial courthouse (today's Vancouver Art Gallery), Premier W.A.C. Bennett insisted that the work be kept secret until its official unveiling.[237] Contractors were told to paint the hoarding hiding the fountain green and white (the colours of the ruling Social Credit Party), but Mayor Rathie had a different idea. He decided to issue permits to art students to paint the hoarding panels and give the three best pieces cash prizes.[238]

The Big Paint-In kicked off with a jurisdictional battle between the city and province over the plywood fence and a minor tussle between an artist and a contractor. The city won the day and soon more hoarding was added to create enough space for all the artists who signed up. The surrounding streets had to be shut down to accommodate the throng of spectators who came by to witness the painting of the fence.

Vancouver Sun columnist Jack Wasserman gave his take on the unexpected success of the Paint-In: "The stunt has burgeoned into one of the brightest episodes in our town's recent history. The response has been spontaneous, youthful and exciting ... Everybody has approached the scheme with a single unabashed aim—to have a little fun. It's the kind of thing one takes for granted in San Francisco. Most attempts to promote similar ventures in our town are usually submerged in serious-minded under organization. For a change it was all very San Vancouver."[239]

After the success of the Paint-In here, Calgary, Victoria, and other cities soon followed suit.[240] As for the secret fountain, its December unveiling was upstaged by a major downpour. Furthermore, a prankster had dumped soap in the water, causing it to spew suds.[241]

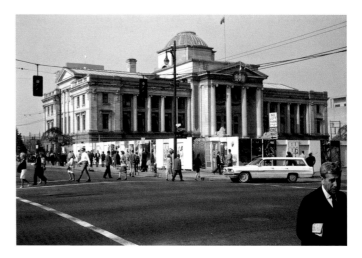

129 *The Big-Paint-In, 1966, Ernie H. Reksten, CVA #2010-006.067*

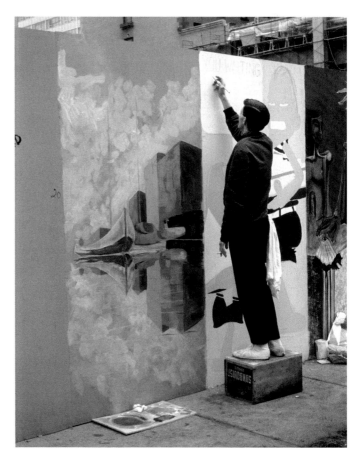

130 *The Big Paint-In, 1966, Leslie F. Sheraton, CVA #2009-001.161*

DOUKHOBOR SONS OF FREEDOM

On January 16, 1963, about 600 members of
the Sons of Freedom faction of the Doukhobor
sect arrived in Vancouver from Hope and settled
in Victory Square. They were on a trek from
the Kootenays to Mountain Prison Institution
in Agassiz where a number of their people were
serving sentences for arson, one of their favourite
protest tactics (along with public nudity). The
Freedomites came to raise public awareness and
pressure the provincial government to investigate
the ongoing problems they had been facing for
years. They also wanted to demonstrate that they
were peaceful, not the terrorists they were por-
trayed as in the media. Hundreds more arrived
the next day, and more after that, until there were
over a thousand Freedomite men, women, and
children in Vancouver.[242]

The Sons of Freedom were dependent on social
workers, charities, and church groups while in
Vancouver, especially in finding adequate accom-
modation. A committee was set up specifically to
address the needs of the children, who were bil-
leted in halls, churches, hotels, and private homes.
Every day the Doukhobors were to be found in
Victory Square singing hymns "with a natural
harmony that was by no means unpleasant," in
the words of historian Eric Nicol, and they quietly
endured verbal abuse from what the press termed
"Son-watchers."[243] The group stayed until August,
then headed to Agassiz, where they set up an
encampment with their hunger-striking comrades
inside the prison. Many of the younger Sons of
Freedom stayed in Vancouver or later returned
and found jobs and places to live. Some of the
older Freedomites also decided to stay, in part
because of the health services available to them in
Vancouver.[244]

131 *Sons of Freedom praying in Victory Square, 1963, VPL #44387*

SKINNY JIMMY THE SQUIRREL

132 *Grey squirrel, LoC #LC-DIG-ppmsc-01742*

Skinny Jimmy was a squirrel living near the Pitch & Putt in Stanley Park. Prior to Easter of 1964, he was a normal squirrel who did normal squirrel things. But for unknown reasons, one day he decided to go on the offensive. By the end of his week-long spree, Jimmy had sent five park visitors to the hospital with squirrel bites. According to witnesses, the little terror "stands on hind legs and taunts his victims after each fight."[245]

Assistant zoo curator Larry Lesage speculated that maybe Jimmy had been teased by some children and was just fed up. "He's not mad," Lesage said, "just a little off balance—like a lot of people." Lesage finally managed to catch Jimmy, getting his finger chewed and bloodied in the process. A *Vancouver Sun* photographer trying to snap Jimmy's mug shot was his final victim.[246] More than a month of solitary confinement seemed to cure the unbalanced rodent, who was back to normal and living in a quieter part of the park in June.[247]

RUSSELL THE GOAT

Russell was a mountain goat who escaped from the Stanley Park Zoo in 1966 and spent much of the next two years living rogue on the bluffs near Siwash Rock, just out of reach of park staff. This was actually Russell's second whiff of freedom; when he was being delivered to the zoo as a juvenile, Russell jumped out of the car window, but was captured after a dramatic chase down Broadway. In 1967, Russell took up a new pastime of jumping from car roof to car roof in one of the parking lots. The following year he met his demise on Park Road, where he was hit by a car.

133 *Linda Gray and Russell the goat, 1966, Gordon Sedawie,*
The Province

134 *Wreck Beach, 2005, James Loewen, Wreck Beach Preservation Society*

WRECK BEACH

The legendary nudist Wreck Beach in Point Grey got its name during construction of the University of British Columbia when ships were sunk there to create a breakwater in 1928.[248] The area was known as *Ulksen* ("the nose") by the Musqueam, who historically used it as a lookout for invaders and as a training ground for youth.[249]

Beachgoers began disrobing at Wreck as far back as the 1920s. In 1970, a recent arrival from California named Korky Day organized a Nude-In to be held at Third Beach in Stanley Park. While he was planning the Nude-In, the

RCMP raided Wreck Beach and arrested thirteen people for indecency. The Nude-In was shifted to Wreck Beach as a result of the raid. Day explained that the new location was better suited because Wreck "is the traditional nude beach and the general public has less chance to be offended at a secluded place."[250] Today, Wreck remains undeveloped, natural, and secluded relative to the city's other beaches thanks to a dedicated group of beach users, making it home to a unique community.

VANCOUVER'S TOWN FOOL

In 1967, Joachim Foikis, clad in a jester's costume, proclaimed himself Vancouver's Town Fool and announced that the city was to be governed by the "magic spell of folly."[251] Foikis had degrees in religion and English literature from UBC, but dropped out of the library program to become a Fool. Years later, he explained that he had had a "very personal experience, an inspiration, almost a mystical experience" that lasted about three years.

Foikis spent those years outside the provincial courthouse (today's Vancouver Art Gallery) reciting Shakespeare and nursery rhymes, dishing out ridicule, riddles, and nonsense, and giving free rides in his wooden cart. The city of Vancouver turned down his application for a grant of $4,000.04 and a fool's licence, but on April Fool's Day the following year, the Canada Council gave him $3,500 for his jestering, which, they said, promoted community self-awareness.[252]

When Foikis was featured in *Look Magazine*, he pointed out that such advertising for the city was worth $50,000 at commercial rates. The magazine gave Foikis a cheque for one cent, the amount he'd invoiced for the article.[253]

Foikis spent the last $500 of his fool's grant on a party. "About 200 derelicts danced, sang, wore daffodils, and even laughed as they took part in a 'happening' at Pioneer Park[sic]," reported the *Sun*. While many people derided the Canada Council for wasting hard-earned tax dollars on a Town Fool, others thought it was well worth it. "Foikis has sparked a vitality here where everything else has failed," said a UBC fine arts professor. "He has planted the seeds of a relaxed humanism. He has peeled off the masks of fear. He's done something to get people mixing together as human beings."[254]

In 2007, Foikis was a seventy-two-year-old pensioner living in Victoria when, while dancing on a wall surrounding the harbour, he fell to his death.[255]

135 *Joachim Foikis a.k.a. the Town Fool, June 1967*, The Province

ZARIA FOR MAYOR

One of the more potent galvanizing forces of
dissent in 1970 Vancouver was Mayor Tom
Campbell. While the media called him "Tom
Terrific," activists from the Youth International
Party, or Yippies, referred to him as "Tom
Terrible" and ran their own candidate in the
1970 civic election. Betty "Zaria" Andrews
was a soft-spoken twenty-three-year-old single
mother on welfare. With silly promises such as
repealing the law of gravity so everyone could be
high, Zaria might easily have been dismissed as
a joke candidate, except that her candidacy high-
lighted the almost complete disconnect of Mayor
Campbell from Vancouver's large population of
young adults. In one example, after declining her
challenge to a boxing match, Campbell exchanged
words with Zaria's supporters who were armed
with toy machine guns and gas masks:

> "Look … you ain't cute. How old are you? What are
> you carrying that toy gun for?"
>
> "I'm twenty-four, and you have liquor on your breath,"
> was the reply.
>
> Campbell shot back: "What are you on … marijuana?"
>
> The Yippie replied that marijuana was not an addictive
> narcotic like alcohol.[256]

Zaria lost the election, but managed to get 848
votes.

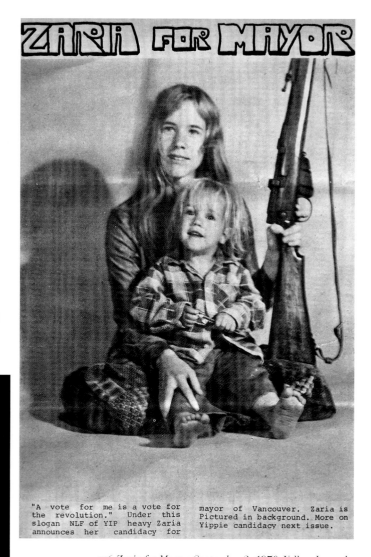

"A vote for me is a vote for mayor of Vancouver. Zaria is
the revolution." Under this Pictured in background. More on
slogan NLF of YIP heavy Zaria Yippie candidacy next issue.
announces her candidacy for

136 *Zaria for Mayor, September 2, 1970,* Yellow Journal

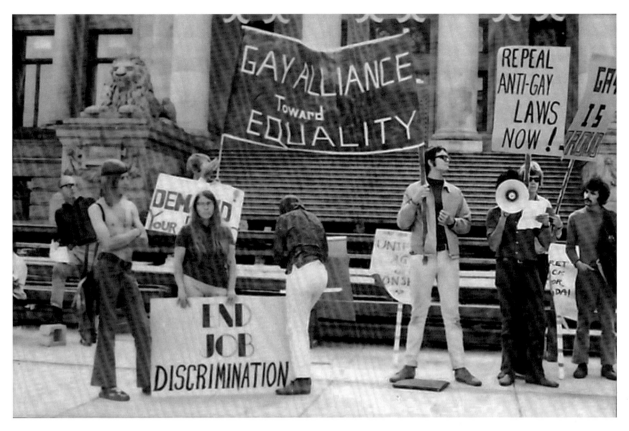

137 *First Gay Liberation Demonstration in Vancouver, 1971, CLGA*

FIRST GAY LIBERATION DEMONSTRATION

Canada's national gay rights movement was launched on August 28, 1971 with concurrent "We Demand" demonstrations at the Vancouver Court House (where twenty people participated) and on Parliament Hill in Ottawa, where there were several hundred. The two rallies were timed to coincide with the second anniversary of Bill C-150, the legislation that decriminalized homosexual acts in private between any two persons over the age of twenty-one. Bill C-150 is a milestone in Canadian human rights history, but it did not bring legal equality. The protesters targeted federal policies with their ten demands, including the removal of references to homosexuality from the Immigration Act and vague terms such as "gross indecency" from the Criminal Code, as well as equal legal rights with heterosexuals.[257]

138 *All Seasons Park, 1971, UBC Special Collections,* Georgia Straight *Collection*

ALL SEASONS PARK

In response to the proposed development of a large Four Seasons Hotel at the entrance to Stanley Park in 1971, a tent city was erected by protesters on the site to block construction. Public reaction to the encroachment on the park was overwhelmingly negative, and the development process was stalled. Members of the Youth International Party (Yippies) concluded that the developer would simply wait until the furor died down and proceed as planned. The Yippies spearheaded the tent city, but soon it took on a life of its own. The encampment, variously called All Seasons Park or the Peoples' Park, lasted for over a year before the government finally relented and cancelled the development.[258] The site has since become Devonian Harbour Park.

139 *The seawall in Stanley Park, 1966, CVA #1502-1000*

STANLEY PARK SEAWALL

The five-and-a-half-mile (nine-km) seawall around Stanley Park was officially opened on September 26, 1971 by H.H. Stevens, the Member of Parliament who had helped spearhead the project in 1914.

The seawall was conceived as a way to prevent erosion of the park's foreshore. Its construction took many decades and proceeded in fits and starts, depending on government funding.

Scottish stonemason James Cunningham was hired to oversee the project in 1917. He began by supervising construction of the lighthouse at Brockton Point. He was a colourful character who took his work so seriously that, one time, he reportedly dragged himself out of bed, where he had been laid up with pneumonia, and headed down to the wall in his pyjamas to supervise his workers.[259] Cunningham worked on the seawall until his death in 1963, when his ashes were enclosed within it (near Siwash Rock).

The wall is made from rocks found on the beach and elsewhere, including cobblestones from Vancouver's old streetcar tracks and recycled tombstones from Mountain View Cemetery.[260]

Another ceremony was held in 1980 after all the gaps were filled in to make the wall a continuous ring around the park. It has since been extended well beyond Stanley Park and now covers about fourteen miles (twenty-two km) of Vancouver's inner harbour, and is popular with pedestrians and cyclists alike.[261]

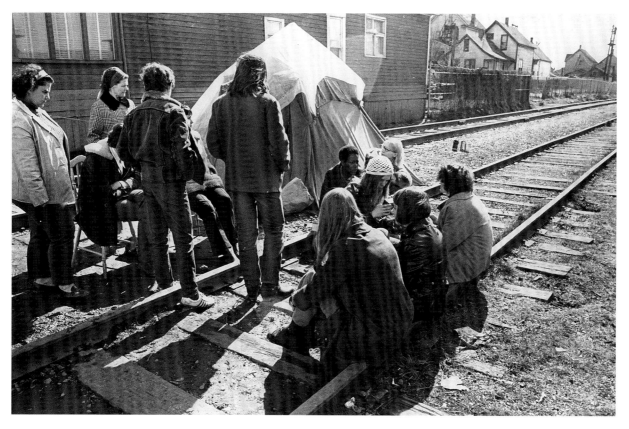

140 *Raymur Moms blocking train tracks in protest, March 24, 1971,*
Gordon Sedawie, The Province

RAYMUR MOMS

After years of watching their children cross busy
train tracks to get to Seymour Elementary School,
in 1971 mothers from the Raymur Housing
Project in Strathcona took matters into their
own hands. They set up a protest camp right on
the tracks, blocking the important rail corridor
that carried goods between the Fraser River and
Burrard Inlet. The protest came after the women
had exhausted all other avenues to get the city of
Vancouver and/or the Canadian National Railway
to build a pedestrian overpass to allow children
and others to cross the tracks safely.[262] The protest
worked, and the city built the overpass. Buoyed
by their victory, the mothers' next goal was to
agitate for what would be Ray-Cam Community
Centre, which opened in 1979.

FREEWAY FIGHT

Planning for a Vancouver freeway system for Vancouver began in the 1950s, following the lead of other North American cities. Rationales for the scheme included connecting to the federal highway system, creating better connections between Vancouver and the suburbs, and facilitating development on the North Shore of Burrard Inlet. If completed, the freeway would have connected to the Trans-Canada highway in neighbouring Burnaby and added a third crossing to Burrard Inlet. It also would have carved up or obliterated much of the old part of the city and cut off access to the waterfront.

The first phase was to dissect Chinatown at Carrall Street, which raised the ire of the Chinese Benevolent Association and local architects on the grounds that it would kill business and tourism in the area, as well as any possibility for heritage revitalization. From there, opposition ballooned because it soon became clear that the proposals were not well-thought out and failed to consider the impact the freeway would have on the city besides anticipated increases in car traffic.

Widespread opposition to the freeway scuttled the project in 1967. The only segment to be built was the Georgia and Dunsmuir Viaducts connecting East Vancouver with downtown. By 1972, the funds that had already been allocated for a bridge over Burrard Inlet went toward the SeaBus, which has been ferrying passengers across the inlet since 1977.[263]

The freeway fight was about more than just transportation infrastructure. Opponents were equally incensed over what they saw as a secretive and authoritarian process coming out of city hall that resulted in decisions that were ill-informed and did not reflect the needs or wishes of the community. Along with other lesser battles in the late 1960s and early 1970s, the freeway fight set the stage for the defeat of the civic party that had been governing for decades and a shift from grandiose development projects to a more community-centred approach to development.[264]

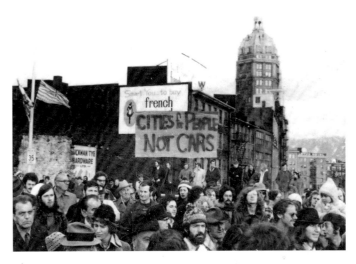

141 *Demonstration against the freeway, UBC Special Collections, Georgia Straight Collection*

192 *Vancouver Sun,* April 16, 1940.

193 *Vancouver Sun,* April 15, 1940.

194 *Vancouver Sun,* April 16, 1940.

195 Cited in John Edward Hasse, *Beyond Category: The Life and Genius of Duke Ellington* (New York: Da Capo Press, 1995), 241.

196 Chuck Davis, "Wait for Me, Daddy," *The History of Metropolitan Vancouver* [website], accessed April 18, 2013, http://www.vancouverhistory.ca/archives_ daddy.htm.

197 Marlatt and Itter, eds., *Opening Doors: In Vancouver's East End: Strathcona,* 191–92.

198 Ibid., 174.

199 *Vancouver Sun,* July 31, 1944.

200 Greg Potter and Red Robinson, *Backstage Vancouver: A Century of Entertainment Legends* (Madeira Park, BC: Harbour Publishing, 2004), 39.

201 Davis, *The Chuck Davis History of Metropolitan Vancouver,* 233.

202 Ibid., 183, 392.

203 *Globe and Mail,* April 23, 2012.

204 "The Five Cent War," *Travesty Productions* [online], accessed July 17, 2013, http://www.travestyproductions.com/film_five_cent.html.

205 Ibid.

206 *Vancouver Sun,* April 14, 1947.

207 Steele, *The Stanley Park Explorer,* 94.

208 Carellin Brooks, *Wreck Beach* (Vancouver: New Star Books, 2007), 45.

209 James Woycke, *Au Naturel: A History of Nudism in Canada* (Toronto: Federation of Canadian Naturists, 2003), 188–89.

210 Jill Wade, *Houses for All: The Struggle for Social Housing in Vancouver, 1919–1950* (Vancouver: UBC Press, 1994), 143–45.

211 Malcolm Lowry, *Hear Us O Lord from Heaven Thy Dwelling Place: Stories* (Ebook: Open Road Media, 2012).

212 *Malcolm Lowry @ The 19th Hole* [online], accessed June 13, 2013. http://malcolmlowryatthe19thhole.blogspot.ca/2011/07/seven-sisters-stan-ley-park-vancouver.html.

213 *ABC Bookworld* (2010) [online], accessed June 13, 2013, http://www.abcbookworld.com/view_author.php?id=2870.

214 Maria Tippett, *Portrait in Light and Shadow: The Life of Yousuf Karsh* (Toronto: House of Anansi Press, 2007), 251.

215 Jill Delaney, "Karsh and the 'Face of Canada,'" in Dieter Vorsteher and Janet Yates, eds., *Yousuf Karsh: Heroes of Light and Shadow* (Toronto: Stoddart Publishing Co., 2001), 187.

216 Ibid., 188, 193. In *Portrait in Light and Shadow* (256). Tippett confirms that the photo captions were penned by *Maclean's* rather than Karsh, though it's not known how much or whether his input was taken into account.

217 Delaney, 193.

218 Tippett, 251.

219 Todd Brendan Fahey, "The Original Captain Trips," *High Times* (November 1991), 38–65.

220 *Vancouver Sun,* December 8, 2001.

221 Shelley Fralic, *Making Headlines: 100 Years of the Vancouver Sun* (Vancouver: Pacific Newspaper Group, 2012), 83.

222 Hunter S. Thompson, *The Proud Highway: Saga of a Desperate Southern Gentleman, 1955–1967,* ed. Douglas Brinkley (New York: Random House, 1998), 138–139.

223 Fralic, *Making Headlines,* 83.

224 *Vancouver Sun,* February 10, 2012.

225 *Ottawa Citizen,* May 1958.

226 *Vancouver Sun,* June 18, 1965.

227 *Saskatoon Star Phoenix,* August 28, 1962.

228 *Globe and Mail,* March 16, 2011.

229 *Vancouver Sun,* September 12, 1959.

230 *Vancouver Sun,* June 5, 1959.

231 *Globe and Mail,* January 5, 2011.

232 *Vancouver Sun,* April 8, 1967.

233 Miller, *The Miller Companion to Jazz in Canada and Canadians in Jazz,* 40.

234 John Dawe, "The Story," *The Original Cellar Jazz Club* [website], accessed March 2, 2013, http://theoriginalcellarjazzclub.blogspot.ca/.

235 Tommy Chong, *Cheech & Chong: The Unauthorized Autobiography* (New York: Simon Spotlight Entertainment, 2008), 31.

236 *Vancouver Sun,* May 21, 1960.

237 *Vancouver Sun,* March 9, 1966.

238 *Vancouver Sun,* April 2, 1966.

239 *Vancouver Sun,* April 5, 1966.

240 *Calgary Herald,* April 30, 1966.

241 *Vancouver Sun,* December 16, 1966.

242 *Saskatoon Star Phoenix,* January 18, 1963.

243 Eric Nicol, *Vancouver* (Toronto: Doubleday, 1970), 234.

244 Roopchand B. Seebaran, "The Migration of the Sons of Freedom into the Lower Mainland of British Columbia: The Vancouver Experience, 1963" (MA thesis, University of British Columbia, 1965), 26.

245 *Vancouver Sun,* April 3, 1964.

246 *Vancouver Sun,* April 4, 1964.

247 *Vancouver Sun,* June 2, 1964.

248 Natalie Joan Hemsing, "Production of Place: Community, Conflict and Belonging at Wreck Beach" (MA thesis, University of British Columbia, 2005), 11.

249 Ibid., 9.

250 Carellin Brooks, *Wreck Beach,* 47–49.

251 Keith McKellar, *Neon Eulogy: Vancouver Café and Street* (Victoria: Ekstasis Editions, 2001), 131.

252 Ric Mazereeuw, "Q&A," *Vancouver Magazine,* April 1998.

253 *Vancouver Sun,* May 25, 1968.

254 Quoted in *The Dependent* [online], accessed June 16, 2013, http://thedependent.ca/news-and-opinion/this-day-in-vancouver/day-vancouver-april-27th/.

255 *Globe and Mail,* June 8, 2007.

256 *Vancouver Sun,* December 3, 1970.

257 Christine Shaw Roome, "The First Gay Rights Demonstration in Canada," *Life as a Human* [online], accessed April 4, 2013, http://lifeasahuman.com/2011/current-affairs/social-issues/this-day-in-history-the-first-gay-rights-demonstration-in-canada/.

258 Lawrence Aronsen, *City of Love and Revolution: Vancouver in the Sixties* (Vancouver: New Star Books, 2010), 124–26.

259 *Vancouver Sun,* February 4, 2005.

260 City of Vancouver, *Discovery Day Self Guided Walk: Mountain View Cemetery, Where Vancouver Remembers* [online], accessed July 9, 2013, http://vancouver.ca/files/cov/mountain-view-self-guided-walk.pdf.

261 *Vancouver Sun,* February 4, 2005.

262 *Vancouver Sun,* January 6, 1971.

263 Ken MacKenzie, "Freeway Planning and Protests in Vancouver, 1954–1972" (MA thesis, Simon Fraser University, 1984).

264 Lance Berelowitz, *Dream City: Vancouver and the Global Imagination* (Vancouver: Douglas & McIntyre, 2010), 82.

INDEX

Page numbers in italics refer to illustrations.

LANI RUSSWURM holds degrees in political science and history from Simon Fraser University. He has been blogging about Vancouver history since 2008 as *Past Tense Vancouver*. He lives with his daughter in Vancouver's Downtown Eastside. *Vancouver Was Awesome* is his first book.
pasttensevancouver.tumblr.com

Vancouver Is Awesome, founded in 2008, is the flagship of the Canada Is Awesome Network and a champion of Vancouver and its culture. The award-winning team at this community-based media company is dedicated to showcasing to residents all of the good things that keep them living in the city, despite the bad. Honing in on positive stories, they encourage people to enjoy their city and all it has to offer, make it even more awesome than it already is, and protect its existing awesomeness. Publishing thousands of stories per year through its popular blog, V.I.A. is supported by a strong social media presence as well as an annual magazine in print. This is *Vancouver Is Awesome*'s first book.
vancouverisawesome.com